BURNING FOREST
THE ART OF
MARIA FRANK ABRAMS

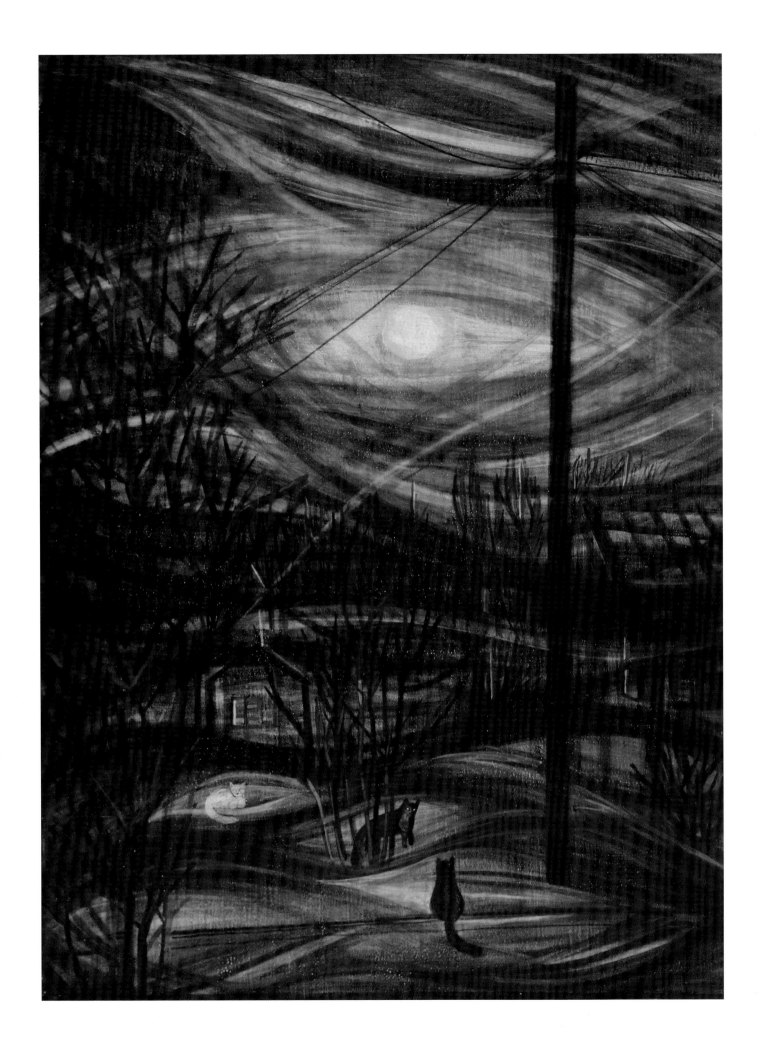

BURNING FOREST
THE ART OF
MARIA FRANK ABRAMS

MATTHEW KANGAS

MUSEUM OF NORTHWEST ART

Published by Museum of Northwest Art
P. O. Box 969
La Conner, Washington 98257
360-466-4446

Distributed by Book Publishers Network
P.O. Box 2256
Bothell, WA 98041
425-483-3040
sherynhara@earthlink.net

Printed in Canada by Friesens
12 11 10 09 08 07 06 05 5 4 3 2 1

LCCN 2010926476
ISBN 978-0-9650722-3-6

Kangas, Matthew.

Burning forest : the art of Maria Frank Abrams / Matthew Kangas ;
foreword by Deborah E. Lipstadt ; introduction by Peter Selz. — 1st
ed. — La Conner, Wash. : Museum of Northwest Art ; Bothell, WA :
in association with Book Publishers Network, c2010.

p. ; cm.
ISBN: 978- 0- 9650722-3- 6
Includes bibliographical references.

1. Abrams, Maria Frank. 2. Artists—Washington (State)— Seattle-
-Biography. 3. Women artists —Washington (State) —Seattle—
Biography. 4. Seattle (Wash.)— Biography. 5. Holocaust, Jewish
(1939-1945) — Hungary— History. 6. Jews—Study and teaching—
Hungary— History. I. Abrams, Maria Frank. II. Title.
ND237.A238 K36 2010 2010926476
759.13— dc22 1006

Designed by Phil Kovacevich/Kovacevich Design
Editorial review by Sigrid Asmus

Cover: *Cool Land—Warm Sky* (detail), 1983, casein on paper,
38 1/2 x 28 1/2. Museum of Northwest Art, gift of Sydney Abrams and Maria Frank Abrams, 08. 208.48.

Frontispiece: *Cats and Moon*, 1953, oil on Masonite, 24 x 18 1/4 . Dr. Cyrus and Mrs. Grace Rubin collection, Mercer Island, Washington

Colophon: *Untitled (Gray and Black Bars)*, colored pencil and crayon on paper, 21 1/4 x 25.

Back cover: *Beyond Summer's Fields*, 1978, oil on canvas, 40 x 50. Joseph E. and Ofelia Gallo Collection, Modesto, California

"The Lock Gate" is reprinted with permission from *Poems of Paul Celan*. Translated by Michael Hamburger. New York: Persea Books, 1988, 169.

Maria Frank Abrams is represented by Gordon Woodside/John Braseth Gallery
2101 Ninth Avenue
Suite 102
Seattle, Washington 98121
206-622-7243
www.woodsidebrasethgallery.com

CONTENTS

The Heart of the Night, 1983
Casein on paper,
38 ¾ x 28 ½
Gift of Sydney Abrams and
Maria Frank Abrams
Museum of Northwest Art 08.2108.48

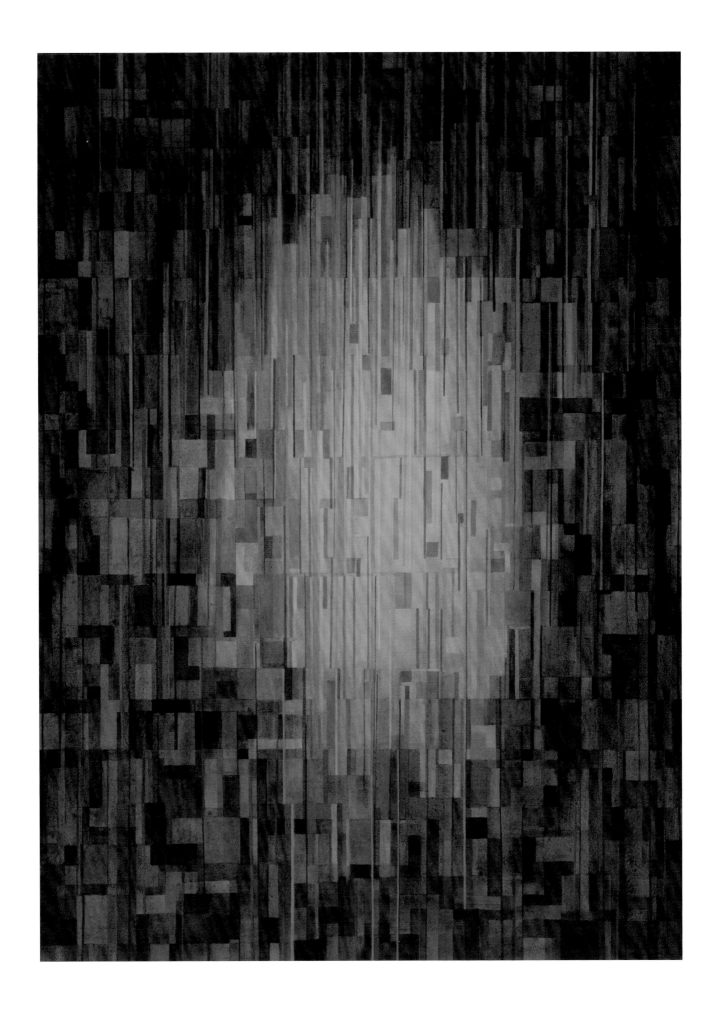

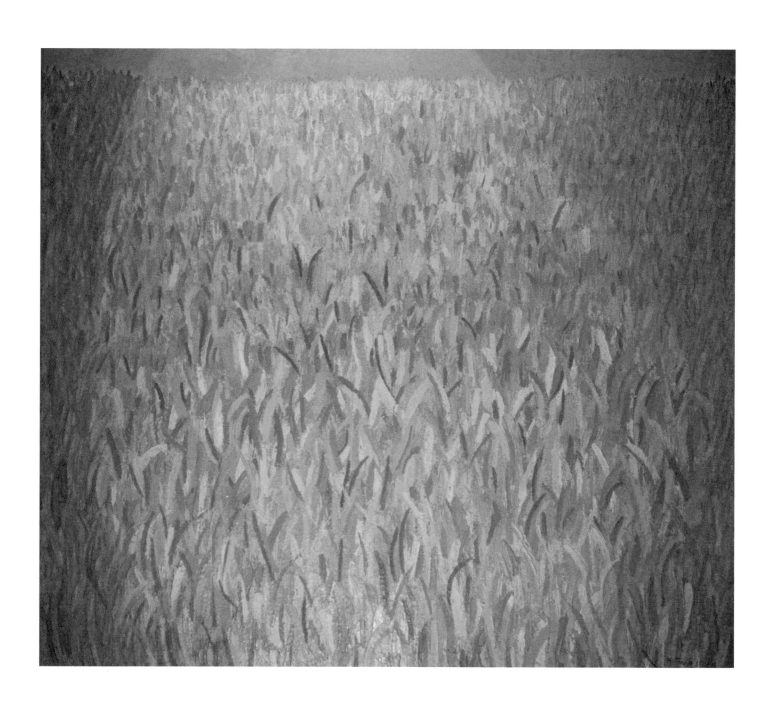

Figure 1
Wheat Field, 1964
Oil on canvas,
42 x 48 ½
Collection of MacDonald, Hoague and Bayless, Attorneys

PREFACE
Előszó

Peter Selz

Maria Frank Abrams is one of the rare survivors of the death camps who was able to establish a career as a distinguished artist. Amazingly, art *was* actually produced in the camps, as in Terezín near Prague, a Potemkin village that the Gestapo called the "Paradise Ghetto" to fool the International Red Cross into believing that it was a normal resettlement center. Outstanding painters, sculptors, writers and, especially, musicians performed in Terezín. But it was a camp of death and those who did not die there of starvation were sent to Auschwitz, never to return.

Marika Frank was born in 1924 to a well-to-do family in Debrecen, Hungary. In 1944, after the German army occupied Hungary, the country's Jews were rounded up and transported to Auschwitz-Birkenau, Poland, where two and one-half million people, including the members of her family, were sent to the gas chambers. She survived and was sent from Auschwitz to Bergen-Belsen, a death camp in Germany and the place where Anne Frank died of typhus, which was prevalent in the camps. In the winter of 1945, after the Soviet army advanced into Prussia, Maria was sent to an internment camp in Magdeburg, Germany, and soon set free. She managed to get back to Hungary and then later enrolled in a vocational craft school in Stuttgart, Germany. There she obtained a scholarship from the Hillel Foundation to study at the School of Art at the University of Washington in Seattle.

Maria Frank Abrams gives credit to the teaching of Walter F. Isaacs, who was head of the School of Art. Trained in Paris, Isaacs had connections to avant-garde artists and brought several of them to Seattle. Among them were the German modernist Johannes Molzahn

and the Russian sculptor Alexander Archipenko, both of whom had earlier been on the faculty of László Moholy-Nagy's Institute of Design in Chicago. Amédée Ozenfant, the French Purist painter, also taught there for a short time. His influence, as well as that of his fellow Purist, Fernand Léger, can be seen in the work of Wendell Brazeau and Spencer Moseley, who were Abrams's fellow students and had actually gone to Paris to study in Léger's atelier. The abstract painter Raymond Hill was one of Abrams's teachers and in 1954 she took private classes with Mark Tobey. Pictures like *Untitled* (1955), with its plethora of angular lines, or the colorful *Untitled (Stick Figures in Grids)* (1959) show her interest in Tobey's painting. And the master himself was one of the first to acquire one of her artworks, *They Hold His Arms Up Until the Sun Sets Down—Exodus* (1952) (Figure 2).

In her interview for the Archives of Northwest Art with Sally Swenson, Abrams mentions that Paul Klee was "a revelation—in every way—[the] spirit and poetic quality of his work . . . " This is apparent in *Aquarium* (ca. 1952), an early Abrams work on paper, as well as in canvases like *Abstract* (1955) and *Many Moons* (1957). In these pictures we see references to Klee's playful fantasies and his meditations on unexplored phases of nature, as well as his unique sense of rhythmic color composition.

During her student days, Maria Frank Abrams made figure studies such as *Interior* (1950) wherein tall female figures are seen against an ominous gate that could refer to her memory of the crematoria. There were also early canvases, such as *Untitled (Crouching Figure)* of 1953, in which a pitch-dark landscape serves as the

Figure 2
They Hold His Arms Up Until the Sun Sets Down—Exodus, 1952
Color lithograph, edition of 8
11 ½ x 11 ¼

background for a woman who seems to be caught in a cave, or in *Neighborhood* of the same year, where close-packed shacks are fenced in by branches of tremulous trees—paintings of sorrow and tragedy prefiguring the evocative painting of dismembered body parts, *Ad Memoriam 1944* (1967).

As time passed, Abrams's paintings became less somber. She also was able to enjoy success for her work. As early as 1952 she began having solo shows at the prestigious Otto Seligman Gallery (where Tobey showed his work). In 1957, she was given a solo show at the Seattle Art Museum and, in 1962, she was commissioned by the Seattle Jewish Community Center to design the sets for a performance of a new opera, *The Dybbuk*, which was followed later that year by her set designs for Verdi's *La Traviata* presented by the newly formed Seattle Opera.

The leading Northwest painters, Mark Tobey, Morris Graves, Kenneth Callahan, and Guy Anderson, established a unique regional style of landscape painting in which hills, valleys, and the sea, as well as flora and fauna, are painted with a swift, energized brush in gen-

erally dark colors, often with mythic undertones. Maria Frank Abrams frequently worked in this vein, as can be seen in the strange humanoid apparition standing at the bottom of the sea in *Untitled (The Visitor)* (ca. 1959). During the 1960s and for years thereafter she painted in this mode. At times she chose bright colors, as in *Wheat Field* (1964), in which almost the entire canvas is covered in bright red and yellow, with only a thin stripe of blue indicating the sky on the top of the painting. The marsh grasses in *Flowing Organisms* (ca. 1960) and the imaginary houses and tower in *Floating City* (1972) show a deep understanding of Paul Klee's rich visual vocabulary. The experience of light in the Northwest is brought to us in canvases like *Opalescent* and *October Sun*, both done in 1973. Fine works on paper such as *Untitled* (1977) and *Cool Land—Warm Sky* (1983) are totally abstract. Here the configurations of form and color are the sole subject of the work.

In the 1980s Abrams again returned to painting the landscape. Now, some forty years after her devastating experiences, her memory motivated the artist to create dark pictures in which depth of feeling is conveyed with the craftsmanship of a seasoned artist. A work like *Black Clouds I* (1996) (Figure 3) depicts land and sky in a painful encounter.

Maria Frank Abrams told Sally Swenson in her interview that she began painting and drawing as a child of five or six years and that in the death camps she would draw on rags or any material she could find. This helped her in her struggle for survival. "Being a painter is living—it is my life." The act of making art was an experience of healing as well as an affirmation of life.

Figure 3
Black Clouds 1, 1996
Prismacolor pencil on paper
16 ¼ x 17 ¾

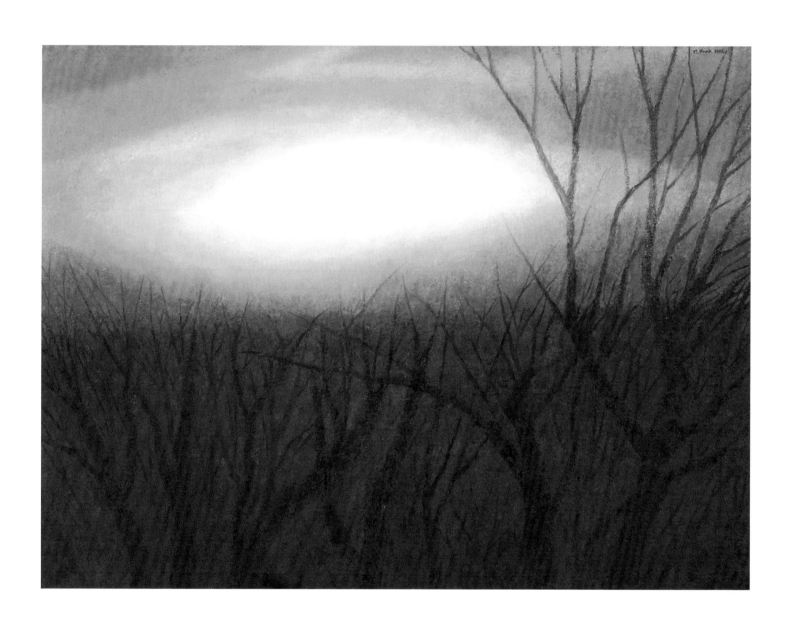

Figure 4
After Winter Storm, 1986
Oil on canvas
40 x 54
Courtesy of Gordon Woodside / John Braseth Gallery

FOREWORD
Előszó

Deborah E. Lipstadt

Fresh out of graduate school, burdened by a mountain of debt, the last thing I was primed to do was buy original artwork. I was slowing emerging from the lifestyle of a graduate student into the existence of a young assistant professor. I had a good job and was beginning to indulge in some material comforts. Though my small apartment was decorated with posters, I had actually framed some of them. No longer did my bookshelves consist of wood bought directly from the lumberyard and bricks scavenged from haphazard sites. Those had been replaced with real bookcases. Even the old broken-down, secondhand sofa was gone and a nice new one in its place. One thing, however, that was not even remotely included in my budget was original artwork. Yet there I stood in a gallery in Seattle looking at a drawing and I knew I had to have it.

A few weeks earlier Marika Frank had come to the University of Washington to talk to the students in my course on the Holocaust. Shortly before the semester began I had seen her at a social event. When she mentioned that she was a survivor, I impetuously said: "Will you come speak to my class?" She hesitated long enough for me to wonder if I had committed a faux pas. Then, in a tone that could not be described as enthusiastic, she said: "Yes, I will do it." She sat before the class and in a still, small—almost flat—voice described her journey from a comfortable family home in Debrecen, Hungary, to a "tour" of concentration of camps that included Birkenau, Bergen-Belsen, Buchenwald, and Magdeburg.

As she spoke of family loss and of intimate details —how women stopped menstruating in the camps— the class listened in riveted attention. Many of them, it was clear, had never heard a survivor speak of their ex-

periences. This was in 1976, before courses on the Holocaust or, for that matter, museums and memorials had become almost commonplace. No one was creating video archives of survivor testimony. There were few high school or college teachers asking survivors to come to their classes. And, for that matter, there were few survivors anxious or even willing to come speak.

Though her time in the camps long predated her training as an artist, even then Marika had a natural eye for detail. She told us about the barracks, the topography, and even the weather. She spent some time describing the *Appel* when all the prisoners had to stand muster as attendance was taken. It began before dawn and sometimes stretched for hours until the sun was high in the sky. The hardest moments came in the lull between the end of night and the rising of the sun. Even though streaks of yellow already marked the sky, this was the coldest period, Marika said. It was colder than the sheer black of night. Standing in their threadbare dresses and mismatched, clumsy shoes, Marika and the other women shivered and sometimes even shook from the cold. In a few short months she had come a terribly long distance from her parents' comfortable home. Her description of these moments stayed with me.

In her quiet voice, Marika continued to tell the rest of her story. Toward the end, when discussing her life after the war and her emergence as an artist, she stated quite emphatically, "I never paint about the Holocaust."

When the bell rang signaling the end of the session no one moved. Finally, after a few awkward moments, I stood up from my chair to signal that class was, indeed, over and it was OK to leave. As the students departed, they approached her and said with more tenderness than

one usually hears from a college student, "Thank you for telling us your story." When the last student had filed out she turned to me and said "Well that wasn't too bad for the first time." Only then did I learn that she had never told her story publicly before.

A few weeks thereafter I received an invitation to her art show. I walked around gazing at the various pictures. I was struck by their beauty. I could imagine them on my walls but, given the realities of my situation, I did not even consider buying them. Then I came upon a small drawing (Figure 5). It was composed of different shades of grey. There were rows of sharp angular shapes along the bottom half. Atop these figures a large band of yellow stretched across the image. Above it were a couple of grey stripes, and toward the very top a smaller band of yellow flecked with grey. Had I not heard Marika's story, I might have thought the angular shapes were trees in deep winter when everything had been stripped from their branches. But I knew that was not what I was seeing. This was the *Appel* at the moment when the sun was beginning to rise. This was the coldest and most difficult moment.

I went looking for Marika. I asked her to look at the picture with me. When I told her what I saw, she smiled and said: "I don't paint about the Holocaust." Unconvinced, I bought the drawing. It has hung in my house for the last thirty years. Each time I look at it I see the *Appel* Marika has so vividly described.

I think of how she has subsequently told her story to countless students in the intervening years. I think of how she never aggrandized or spoke dramatically but just stuck to the "facts."

But I don't only think of her suffering and what she has endured. I think of what she has accomplished, of the amazing life and career Marika has built since those cold, dark mornings. Nothing can return to her the family members who were killed. Nothing can mitigate the horrors of her experience. Yet the beauty of the work she has produced in the ensuing years is a testimony to the way in which she has embraced life with resiliency, dedication, and grace.

Out of the dark, cold mornings of the *Appel,* she has made this world a far more beautiful place. For that we are very grateful.

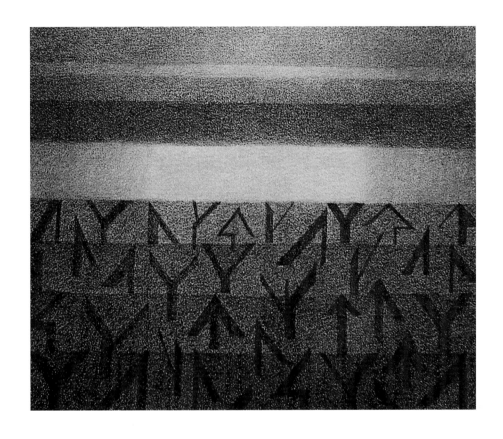

Figure 5
Winter Woods, 1975
Colored pencil on paper
10 x 12
Deborah E. Lipstadt collection, Atlanta, Georgia

The Lock Gate

Above all this mourning
of yours: no
second heaven.

.

To a mouth
for which it was one of a thousand
I lost—
I lost a word
that had remained with me:
sister.

To
the worship of many gods
I lost a word that was looking for me:
Kaddish.

Through
the lock gate I had to go
to save the word back
to the salt waters and
out and across:
Yiskor.

(from *Poems of Paul Celan*. 1988, 169.)

Figure 7
Untitled (Optic Sunrise), 1966
Casein and watercolor on paper
28 x 20 ¾
Gift of the artist
Jundt Art Museum, Gonzaga University, Spokane, Washington

Journey to Freedom

Utasáz a Szabadság Felé

The art of Maria Frank Abrams (b. 1924) came about as a result of her 1948 emigration to the United States from Stuttgart, Germany, and, before that, from Debrecen, Hungary. Arriving with her cousin Vera Frank (b. 1924) who, with Maria, had also survived Nazi concentration camps and lost virtually all her family members, Marika Frank (as she was then known) traveled to Seattle from New York by train after brief stops in Gary, Indiana, and Chicago. They were met at the King Street railroad station in Seattle by two other survivors, one of whom was the future Congressman Tom Lantos (Democrat, California, 1928–2008), the first Holocaust survivor to be elected to Congress and, at the time, an undergraduate student at the University of Washington. The other one was Imre Rachelitz, who became a renowned international lawyer.

Marika's enrollment as a freshman at the University of Washington soon followed, for both she and Vera had received full-tuition and living-expenses scholarships from the U.S.-based Hillel Foundation, an on-campus Jewish student support organization that helped Nazi victims. During the next three years, Marika flourished, improving her English rapidly, marrying her husband, Sydney A. Abrams (b. 1927), a fellow UW student, and completing her Bachelor of Fine Arts degree with honors in 1951. She also gave birth to her only child, Edward, in 1952 (named after her father, Ede).

A chance meeting with the area's leading artist, Mark Tobey (1890–1976), at the Finnish-American John Uitti's frame shop and gallery on University Way in 1952, led to the first sale of her art to Tobey, the print *They Hold His Arms Up Until the Sun Sets Down—Exodus* (1952), and an invitation to study privately with the aging master once her studies were finished. She had graduated summa cum laude from the School of Art in 1951. Tobey, in turn, recommended the talented young European woman to his dealer, Otto Seligman (1890–1966), himself an exile from Hitler and the brother-in-law of composer Arnold Schoenberg (1874–1951), who gave her the first of four solo and five group exhibitions at his Seattle gallery. Marika Frank had become a full-time professional artist.

However, as some of the paintings, prints, and drawings executed over the next decade reveal, and as Peter Selz mentions in his Preface, she was still grappling with the nightmares and memories of the ten months she spent in Auschwitz, Bergen-Belsen, and Magdeburg between July 1944 and April 1945. In order to better understand why these artworks were made and then later played down by the artist in interviews, it is necessary to trace briefly her background in Hungary, as well as that of her ancestors and immediate family members. Their achievements, triumphs, vagaries, eventual deportation by Hungarian gendarmes, and murder by Nazi authorities, have had a lifelong impact on the artist. This was expressed indirectly and symbolically in the paintings of the 1952–1966 period, and also in more subdued, slightly less evident ways in her subsequent, seemingly nonfigurative, non-narrative and nonpolitical art that followed.

This book traces those roots as well as their flowering into an artistic oeuvre of great talent, power, strength, and beauty. In the process of an examination of her development, the reader will learn, from Abrams's own words, the accounts of her oral history recorded and transcribed at various points in her life, but, chiefly, in three interviews conducted in 1974,[1] 1976,[2] and 1995.[3] Among the three major interviews, there are oc-

casionally minor discrepancies and possible contradictions, but for our purposes her voice clearly conveys the course of the narrative of her early life so that we may better observe the reasons for the eventual path of her artistic growth: as a landscape artist rooted in nineteenth- and early twentieth-century Hungarian art; as a public artist and theatrical scenic designer openly participating in mid-century American visual arts culture, and as a modernist abstract artist responding to trends in both postwar European art (which she saw firsthand at Seligman's) and in American art, as when she shifted to a type of systematic, geometric abstraction in the mid-1970s.

Marika Frank's childhood and youth were bathed in a middle-class glow of love and family affection. As she told one interviewer, "I had a wonderful childhood."[4] The safety and security, comfort and enjoyment, of her family's home in Debrecen, Hungary, the country's third-largest city though a relatively smaller one, was confidence-building. Their successive homes at Török Bálint utca 19 and Piac utca (Market Street) 32 provided the perfect backdrop for a budding artist, one whose father "always kept all my work and was very proud of it"[5] (Figure 8). She amplified, "Art education in Hungarian schools was terribly bad, but I managed to go on painting and drawing nonetheless." She also mentioned to another interviewer, "I enjoyed doing illustrations to the children's stories that were read to me."[6] This is revealing in that, when she later studied for and received a Master of Library Sciences degree from the University of Washington, her main area of interest was children's literature. In addition, she created a full, as-yet unpublished set of illustrations for the story of King Midas.

The earliest of her family tombstones in the Jewish cemetery in Debrecen have the name Rozensweig on them and memorialize ancestors born as early as 1779. Later in the nineteenth century, after the emancipation of Jews under the Habsburg Empire in 1867, her maternal ancestors changed their name to Rózsa, Hungarian for rose. Considering that the restrictive laws passed against Jews in twentieth-century Hungary made clear separations between Hungarians and other citizens who were Jews (referred to in documents as "Hungarians and Jews"), it is perhaps surprising that Marika Frank's family had not only been in Hungary so long, but that her great-grandfather, the son of a goldsmith in the nearby village of Hajdusamson, had also been the third Jew permitted to move into Debrecen from his village in order to set up a state-licensed pawnshop. Prior to 1840, Jews were not allowed to settle in cities.

Despite the seesawing of permissions

Figure 8
Ede Frank and Marika Frank, Debrecen, Hungary, 1943

and restrictions, such as the university admission quotas put on Jewish male students in 1920, the Rózsa and Frank families flourished, so much so that a steadily rising standard of living in the 1920s, continuing after recovery from the Depression of the 1930s, allowed swimming pool parties at local public facilities and summer vacations in what is now southern Slovakia at one of two villas acquired by Marika's grandfather. At the same time, as early as 1937 in Germany, diarist Victor Klemperer noted what was in store for Hungarians very soon:

> August 17, 1937, Tuesday
> In the *Stürmer* (which is displayed on every corner) I recently saw a picture: two girls in swimming costumes at a seaside resort. Above it: "Prohibited for Jews," underneath it: "How nice that it's just us now!"[7]

These were idyllic times for the growing family. Besides her parents, two cousins had also joined the family after the death of a parent (Figure 9). All of this would come to an end on March 19, 1944, when the German army occupied Hungary. Adolf Eichmann (1906–1962), head of the Reich Security Main Office section on Jewish affairs, began personally supervising the con-

Figure 9
Left to right: Cousins György Faragó, Marika Frank, and Tibor Rózsa, ca. 1941

centration of Hungarian Jews in ghettoes and their transport to the death camps with the collaboration of the Hungarian government and the active assistance of the Hungarian army and gendarmerie.

Despite the reluctant vacillation of Hungary's "regent ruler," Miklós Horthy (1868–1957), in attempting to forestall these events as long as possible, the momentum of Hitler's Final Solution found enthusiastic participants in Hungary's widespread radical-right splinter groups such as the Arrow Cross and Hungary's own version of the Ku Klux Klan, Awakening Hungary.

Long before Admiral Horthy (who had been in charge of the Mediterranean fleet under the Habsburgs in World War I) or the university quotas of 1920 (called *numerus clausus*), Hungary was already, as one historian put it, "ahead of all the rest of the world in introducing a system which later became known under its Italian name of fascism. Its substance was worship of the nation and punishment for non-conformism."[8]

Out of a Hungarian population of 8.7 million in 1930, 5.1% were Jews, the highest percentage in Central Europe. With the tacit support of the Roman Catholic Church, which veiled its anti-Semitism in anti-capitalism, the first, second, and third anti-Jewish laws, each increasingly restrictive, were passed in May 1938, May 1939, and early 1941. Once Hungary's mutual defense pact

with Germany was signed in a vain attempt to regain lands lost after World War I in western Romania, northern Yugoslavia, and southern Czechoslovakia, young Jewish men were forcibly drafted into labor service battalions while Jewish soldiers already in the Hungarian army were disarmed and transferred from their units to the labor battalions. The Jewish labor servicemen, poorly clad and supplied, forced to wear discriminatory yellow armbands and often brutally mistreated, were sent to the Russian front to perform the most dangerous tasks, dig trenches, and clear minefields. Admiral Horthy's belated withdrawal from the Axis pact on October 15, 1944, and his lame attempt to achieve an armistice with the Soviet Union only guaranteed a German-supported coup that put the fascist Arrow Cross (*Nyilas*) in power and installed Ferenc Szálasi as führer of Hungary.

Even though Admiral Horthy ordered a halt to the deportations on July 8, 1944, it was already too late. Eight hundred twenty-five thousand Hungarian Jews (including those living in the areas annexed to Hungary) had faced deportation, representing at that moment in history the "largest single Jewish community in Europe."[9] The deportations had begun in mid-May 1944 and reached Debrecen by late June. Out of the 437,000 who were rounded up nationwide, only 116,000 survived the camps or escaped. In Debrecen, out of a prewar population of 12,000 Jews, 4,000 to 4,500 survived.[10] Today there are 1,000 Jews in Debrecen, including some survivors who emigrated to Israel after the war

Figure 10
Center: Site of original Rózsa Clothing Store, Debrecen, Hungary, 2009

but later returned to Debrecen after the fall of Communism in 1989. Sixty-three thousand Hungarian men perished in the labor camps, including many relatives and friends of Marika Frank; only 20,000 labor servicemen survived the war. In all, 564,000 Hungarian Jews perished in the Holocaust.

Marika's family, like almost all of Hungarian Jewry, had no idea what lay ahead and contended as best they could. After the second anti-Jewish law placed in jeopardy Jewish-owned businesses, Mr. Frank's men's clothing store was signed over to non-Jewish employees and a gentile relative-by-marriage in Budapest (Figure 10). When the SS conducted a search in their apartment, the family first decided to move into the large Rózsa family home where her aunt and eight-year-old cousin were living, believing they would be safer there. Soon thereafter, they were all moved into the new Debrecen ghetto surrounding the smaller of the city's two synagogues. After a few weeks, on June 21, 1944, everyone was shifted to a brick factory yard on the outskirts of town to wait—with little food or water—for the trains to arrive.

Abrams has discussed her successive stays in Birkenau-Auschwitz, Auschwitz, Bergen-Belsen, and Buchenwald-Magdeburg in detail in the oral histories and newspaper interviews. Without detailing them more fully here, it is worth noting her sanity-saving artistic activities during her incarceration. As she told Janice Englehart of the Steven Spielberg–funded Shoah Project interview in 1995, "I cannot possibly describe the horror of everyday existence." Even so, she continued, "I did use my art. . . .Women would come to me to ask me to draw the kinds of clothes you wore in normal life. This showed the spirit we still had."[11]

Primo Levi (1919–1987) gives a gripping account of his experiences in *Survival in Auschwitz*. Like Marika Frank, he was stricken with scarlet fever and

> On January 11, 1945, [I] was once more sent to Ka-Be. "*Infektionsabteilung*": it meant a small room, really quite clean, with ten [bunks] on two levels, a wardrobe, three stools and a closet seat with a pail for our corporal needs. All in a space of three yards by five.[12]

Another account of the train trip from Hungary has been recorded by Nobel-prizewinning author Elie Wiesel in his classic *Night*. He notes a chillingly prophetic incident concerning a neighbor and family friend in the boxcar with him

> Madame Schächter had gone out of her mind
> . . .
> "Fire! I can see a fire! . . . Look! Look at it! Fire! A terrible fire! Mercy! Oh, that fire! . . . Jews, listen to me! I can see a fire! There are huge flames! It is a furnace!"[13]

Marika Frank's transfer from Auschwitz to Bergen-Belsen (where her stay coincided with that of the diarist Anne Frank, 1929–1945)[14] culminated in her release at Magdeburg, Germany. Shortly after that, on April 17, 1945, without German guards present, she witnessed the historic encounter between U.S. Army and Red Army soldiers. In her case, this occurred at Zerbst on the Elbe River. "I met the first Americans and . . . saw the Americans and Russians meet. I will never forget that."[15]

Via a variety of circuitous routes, she returned to Budapest where she was reunited with some cousins who had "survived the war in hiding. . . . They didn't see things the same way I did."[16] Aware by now that her parents and other family members had perished upon arrival at Auschwitz, she soon joined her cousin Vera Frank and two girlfriends in Austria where they had obtained jobs as secretaries with the United Nations Relief and Rehabilitation Administration (UNRRA) in the autumn of 1945. By the time Marika arrived in Linz, Austria, Vera had been hired as a receptionist and interviewer for the American-Jewish Joint Distribution Committee (JDC) and, thanks to Marika's spotty grasp of English, gained a comparable job for her cousin.

The two young women, now both twenty-two, were soon sent to work for another JDC official in Stuttgart, Germany. According to Vera, Marika attended a local art school after work for about six weeks but felt uncomfortable overhearing anti-Semitic remarks by classmates. While still in Linz, they learned of the Hillel Foundation's scholarships to American universities. Both decided to apply, received the scholarships, and, after a long wait for visas, a transatlantic ship crossing from

Bremerhaven, and stops in New York, Indiana, and Chicago, they arrived in Seattle on February 8, 1948. As we shall see, it was the beginning of a new life.

In the coming years, Marika Frank became Marika Abrams, then Maria Abrams, then M. Frank, and finally Maria Frank Abrams. Because of widespread discrimination against women artists in regional art competitions, she began signing her paintings M. Frank and continued to do so for at least a decade. As she noted in a 1967 interview, such discrimination was all "Probably a hangover from the days when one had to prove one's worth by building one's own log cabin—something few women could do!"[17]

Perhaps partly as a result of her harmless subterfuge, she began to win numerous awards. With her successful academic career crowned by marriage to Sydney in 1948 and the birth of her son, Edward, in 1952, Marika Frank had overcome great adversity and triumphed over seemingly insurmountable odds. Initial newspaper interest in her work took the predictable form of headlines like "Busy Life Dims Memory of Nazis,"[18] "The Nightmare of Nazi Horror Camps Fades as Maria Abrams Transfers Her Moods to Canvas,"[19] and "She Was with Anne Frank."[20] In general, Maria Frank Abrams found her new friends and neighbors had little interest in her experiences of World War II. Postwar Seattle, like most of postwar America, was intent on a happy-face, optimistic, and conformist lifestyle. With the advent of the Cold War and the McCarthy era (which, as we shall see in Chapter Three, involved Abrams in a minor local controversy), Soviet Communism replaced Nazism as the enemy.

Could this lack of interest be the reason Abrams seemed to stop dealing with such issues in her art? Except for *Sorrow* (1957), and *Ad Memoriam 1944, Parting*, and *Remembrances* (all 1966), the concentration camp events were dealt with earlier—even, in a few cases, while she was still a student at the School of Art. It seemed as if Abrams had sought closure on the period by moving on to fantasy village scenes and Northwest landscapes. These became widely desired by collectors through her frequent gallery shows.

And yet, as the following examinations of her oeuvre seek to prove, the nightmare of Auschwitz returned unaccountably and with greater subtlety in her middle-

and late-period works. Ominous sooty weather (*Black Clouds*, 1996) could be ash from the crematoria chimneys. The horizontal and vertical bars of her abstract period might stand in for the fences and barriers, the barbed wire of the *laager*. Evergreen trees are tinged by fiery red-oranges that may reflect the offstage glow of the death ovens. The burning forest in *Cats and Moon* (1952) is burning because, out of sight yet nearby, the flames of the crematoria are out of control, burning day and night.

Abrams eventually disclaimed attempting to cope with such subjects in her art and, as she later told Englehart, "I never wanted to paint the Holocaust." Deborah E. Lipstadt recounts in her Foreword that Abrams declared, "I never paint about the Holocaust." Nevertheless, the traces and symbols are indisputably there and are discussed at greater length in Chapter Five (Figure 11).

In the years between, as her stature as an artist grew so did her reputation as a respected intellectual who read widely and cultivated friends with ideas. She kept pace with European intellectual trends such as Existentialism, for example, and read contemporary American authors. Her roles as a public artist, mosaicist and muralist, costume and set designer, are discussed in Chapter Four. Her relation to Seligman and his salon of European musicians and artists is explored in Chapter Three. The work of her final period is discussed in Chapter Six; culminating with her last paintings and drawings in 2002, it was supplemented by the four Holocaust panels executed at the invitation of the Nordic Heritage Museum in Seattle on the occasion of her 2002 retrospective there. She was the honoree at the museum's annual Raoul Wallenberg memorial dinner.

In thus marking the beginning and conclusion of her career with artworks that early on had dealt with difficult and painful subject matter and, then, much later in life, treated the murders of loved ones with precise yet creative documentary photographs collaged onto large painted panels, Maria Frank Abrams responded forthrightly to those who, like the German Jewish philosopher Theodor W. Adorno (1903–1969), claimed "No poetry after Auschwitz."[21] That is, many cultural critics like Adorno, a Marxist, believed that the enormity of Nazi crimes against humanity rendered art and culture helpless to counter them with creative acts.

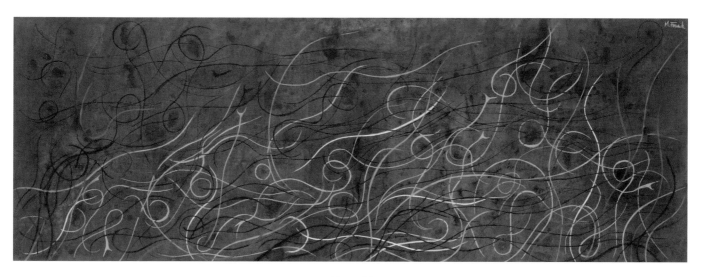

Figure 11
Tendrils, ca. 1958
Casein on paper
8 ¼ x 23 ¼
Gift of Sydney Abrams and Maria Frank Abrams
Museum of Northwest Art 08.208.43

What they did not take into consideration were the needs and artistic rights of Holocaust survivors like Abrams, or the children of Holocaust victims, like the Franco-Romanian poet Paul Celan (1920–1970) whose parents perished in the camps in Transnistria and whom he memorialized in many of his poems.

Abrams's accomplishment of this feat, the creation of art, as well as even a lyrical art like Celan's, after Auschwitz is one of great significance. Paralleling Celan's occasional use of folk or nursery rhymes in which to submerge deeper meaning, Abrams's felicitous, deceptively inviting landscapes can turn into thunderstorms in an instant.

With Chapter Six, "Time Regained," Abrams engages in a Proustian reverie of remembering backward and forward in time. Hers is an art of dualities: for every sunrise there is a sunset; for every sunny field there is a desolate plain; for every exaltation of nature there is the potential of chaos and catastrophe. With her extensive reading and love of literature, Abrams has conducted her own creative dialogue with history, doing so in the widest geographical isolation from Auschwitz, ten thousand miles away in her home and studio on Mercer Island, Washington, where she and Sydney built their architect-designed home in 1958 and where she lives today. Its natural surroundings became the site and subject of many of her greatest paintings.

Far from Adorno's fear of "barbaric" poetry by those who dared to make utterances after the evil grotesqueries of the Final Solution, Abrams conquered such caveats. Not only did she build a vision that allowed her to address such horrendous events obliquely and metaphorically, she also celebrated her survival and new life through her cultural engagements, her extensive travels to Europe and Israel with her husband and son, and her subsequent reconciliation with European art and culture, first with the Seligman circle and then through return trips to Europe, even including Hungary.

Emerging as an artist at exactly the same time Adorno maintained such creative and profound responses were impossible, Abrams challenged critical neo-shibboleths of this kind through mastery of her materials, her professional achievements, and the offering to Americans and others of the life-affirming vision conveyed through her art. Memory may be dark, but in the art of Maria Frank Abrams it has found a key pathway to light.

NOTES

[1] Sally Swenson, interview with Maria Frank Abrams. Archives of Northwest Art, University of Washington Libraries Special Collections, March 20, 1974. Cassette C-90.

[2] Shirley Tanzer, "Mrs. Marika Frank Abrams." William E. Weiner Oral History Library, American Jewish Committee Holocaust Survivor Project, January 15–16, 1976; February 10, 1976.

[3] Janice Englehart, interview with Maria Frank Abrams, Survivors of the Shoah: Visual History Foundation, December 8, 1995. Part I: 1 hr. 40 min.; Part II: 1 hr. 30 min.

[4] Janice Englehart. See also "Selected Writings and Interviews with the Artist" in the Bibliography.

[5] Shirley Tanzer, II: 1-10a.

[6] Sally Swenson.

[7] Victor Klemperer, I Will Bear Witness: A Diary of the Nazi Years 1933–1941. New York: Random House, 1998, 233.

[8] Emil Lengyel, 1,000 Years of Hungary. New York: John Day, 1958, 205.

[9] Miklós Molnar, A Concise History of Hungary. Cambridge, UK: Cambridge University Press, 2001, 292.

[10] Ibid. For the total number of Hungarian Jews deported and the total who perished, see Randolph L. Braham, The Politics of Genocide: The Holocaust in Hungary. Rev. ed. New York: Columbia University Press, 1994, 674, 1298. For Debrecen, see Moshe Gonda, A Debreceni Zsidók Száz Éve. Tel Aviv: Committee for Preserving the Memory of Debrecen's Jews, 1971, 292.

[11] Janice Englehart.

[12] Primo Levi, Survival in Auschwitz. New York: Touchstone, 1996, 151.

[13] Elie Wiesel, Night. New York: Bantam, 1982, 22–23.

[14] Shirley Tanzer, II: 1-7a.

[15] Shirley Tanzer, II: 1-17a–18a

[16] Ibid.

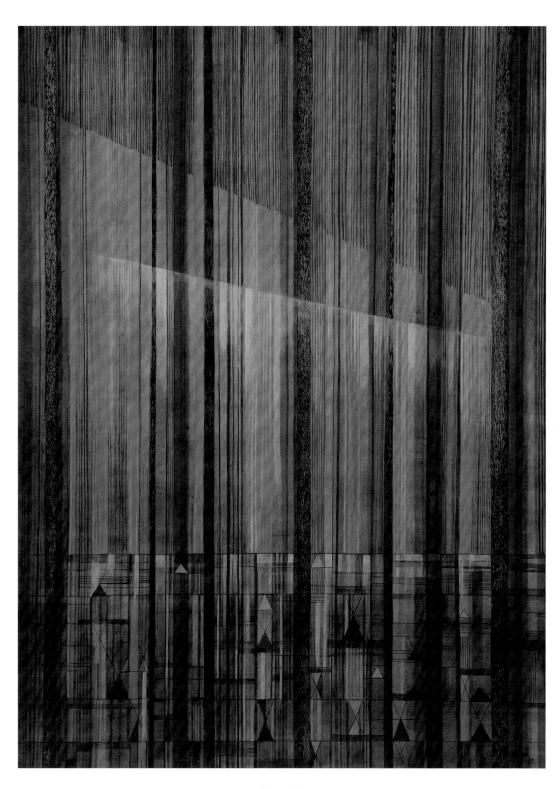

Figure 12
Tranquil Shadows, 1985
Casein and ink on paper
27 ½ x 20 ½
Gift of the artist
Henry Art Gallery, University of Washington 2008.216

[17] Sally Gene Mahoney, "Special Mention: Woman's Role Is Art World Topic for Artist's Speech," *Seattle Times*, December 1, 1967, 23.

[18] Dorothy Brant Brazier, "Busy Life Dims Memory of Nazis," *Seattle Times*, May 8, 1959.

[19] Lucile McDonald, "She Paints 'Fragments of Dreams': The Nightmare of Nazi Horror Camps Fades as Maria Abrams Transfers Her Moods to Canvas," *Seattle Times*, January 24, 1954.

[20] Stuart Gray, "She Was with Anne Frank," *The* (Vancouver, BC) *Province*, February 15, 1967, 25.

[21] T. W. Adorno, "Cultural Criticism and Society," first published in German in 1951; in *Prisms: Cultural Criticism and Society*, Cambridge, MA: MIT Press, 1983. The quotation is actually closer to "Writing poetry after Auschwitz is barbaric."

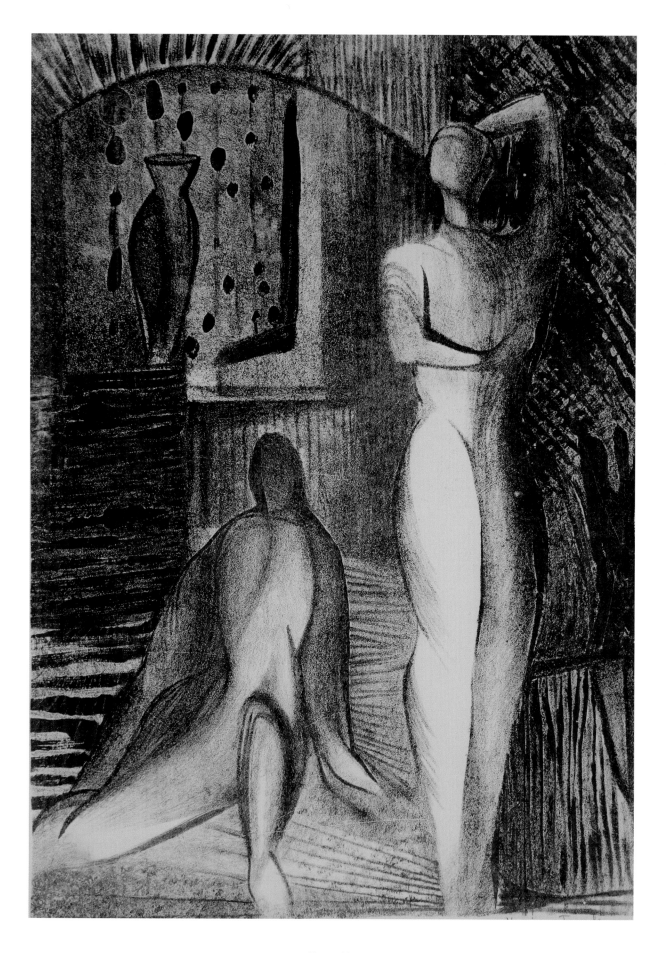

Figure 13
Interior, 1950
Lithograph on paper
Edition of 8
13 x 9
Arthur and Alice Siegal Collection, Seattle

CHAPTER ONE

Schools of Art

Művész-Képző Iskolák

> When I was on my way here, I knew I would like to be in a
> school of art [but] I did not know whether or not this was
> going to be possible. . . I was kind of worried about it, but
> I was [also] very much interested in literature and history.
> — M. F. A., 1974[1]

Little did Marika Frank realize while she was en route to Seattle that the University of Washington School of Art was, under dean Walter F. Isaacs (1886–1964),[2] one of the finest university-based art instruction programs in the nation. In fact, with its pedagogical mixture of French atelier methods and Bauhaus-based principles of equality among all the arts, it would be the perfect fit for the young woman who had made fashion sketches for fellow prisoners. There, she would become a painter, mosaicist, muralist, printmaker, and scenic designer.

Even better, the program she enrolled in, the Bachelor of Fine Arts degree, required humanities courses such as literature and history in addition to the core curriculum of drawing, design principles, still life, live models, and, eventually, painting classes and independent study.

As a child, the young Marika Frank's efforts at painting and drawing were lauded and preserved by her father, Ede. The fashion drawings were made while she was incarcerated and in the displaced persons camp in Linz, Austria, as well as during the period spent waiting for a visa in Stuttgart, Germany. At that time, she attended classes at the Kuenstlerisch Wissenschaftlich, a school that may have included architectural drafting lessons. Her stay in Stuttgart lasted from May of 1947 to January 1948.

One cartoon executed by the artist during her stay in rubble-strewn Stuttgart is a drawing of herself and Vera seated on a bench, probably waiting for a tram (Figure 14). Above them is a shining sun face with a cartoon text bubble in Hungarian: "What! You're still here?" This may refer to their exasperatingly protracted waiting period for passports and visas to the U.S., or to their having overheard the words spoken in German by tram riders who commented to one another on the two young women. It was another omen to them that the time had come to leave Europe. Behind them is a pile of debris with a placard posted on it carrying the words "Old Europe" in English.

Although it cannot be documented fully, it is likely that Dean Isaacs, or "Mister Isaacs" as he was usually referred to, had personally approved her application to the department. Born in the Midwest and educated under Arthur Wesley Dow (1857–1922) at Columbia University, Isaacs had also spent extensive time in Europe, especially Paris, where he was living when called

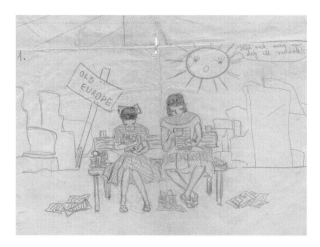

Figure 14
Untitled Drawing #1, 1947
Pencil on paper
5 x 8

upon by University of Washington President Henry Suzzallo to head the newly formed School of Painting, Sculpture, and Design (Figure 15). A senior colleague who was to become the other leader of the department, the Australian-born Postimpressionist Ambrose Patterson (1889–1966), had arrived from San Francisco in 1919 by steamer. Accepting the job with the proviso that he remain in Paris for one more year to study with Othon Friesz (1879–1949), Isaacs arrived in Seattle in 1923, the same year as the man who would become Abrams's other mentor, Mark Tobey.

Over the next three decades, Isaacs hired for part-time, temporary, permanent, or visiting-artist jobs an incredible array of some of the major and minor figures of twentieth-century modern art. Amédée Ozenfant (1886–1966), Paul Bonifas (1893–1967), Alexander Archipenko (1887–1964), Pablo O'Higgins (1904–1983), and Johannes Molzahn (1892–1965), among others, traveled to Seattle to teach Isaacs's faculty and graduate students in special summer seminars or throughout the rest of the academic year. When he could not attract Fernand Léger (1881–1955), he sent his two top students, Wendell Brazeau (1910–1974)[3] and Spencer Moseley (1925–1998)[4] to the Frenchman's private atelier for a year of study in Paris. They returned to become the teachers of, among numerous other students, Maria Frank Abrams.

A mixture of Cubist and Constructivist approaches, Mexican muralism, Purist pottery design, Bauhaus-style craft and interior design instruction, along with the extensive use of still-life and live model drawing classes, the Isaacs curriculum attracted nationwide attention as well as promising students. It was a good training program for the young woman who was slightly older than the other undergraduates. She flourished with the help of two other favorite teachers, the husband-and-wife couple, Ed Rossbach (1914–2002) and Katherine Westphal (b. 1919), both of whom would go on to the University of California, Berkeley, where they would help co-found the fiber arts movement of the 1970s. They preached the significance of textile design and may have tempered Abrams's reservations about the dull folk-embroidery lessons she had been subjected to in elementary and middle school in Debrecen. "In the three years I have taught at the University of Washington," wrote Rossbach in April 1950, "Maria Frank Abrams has been one of the most truly creative and intelligent people I have encountered. She is a stimulating student—in her work, attitude, and participation. She possesses a remarkable ability to fulfill and go beyond the requirements of University courses. I cannot sufficiently describe her sincerity and earnestness, and her fine enthusiasm."[5]

Living in a Jewish sorority, Phi Sigma Sigma, young Miss Frank found it difficult to turn down dates, considering it either bad manners to say "No," or sincerely finding the attention flattering. Looking back at the occasional culture clashes and general immaturity of her sorority sisters, she understood the situation of young American women better once she began reading works like the short story, "Daisy Miller," by Henry James (1843–1916), and the novel, *The Age of Innocence*, by Edith Wharton (1862–1937), both studies of naïveté and the dangers of speaking out openly. She found the latter "A master example of this kind of behavior, where people never speak their minds. There are always misunderstandings."[6]

In the same interview, she alluded to the prominent nineteenth-century Hungarian poet, Endre Ady (1877–1919), who "[h]as a beautiful poem in which he says, 'I want to show myself,' which means 'I want to show myself so I can be seen seeing.'"[7]

Since she was a few years older than many of her classmates, the European-born art student formed a stronger affinity with younger faculty members like Brazeau and Moseley, as well as Raymond Hill (1891–

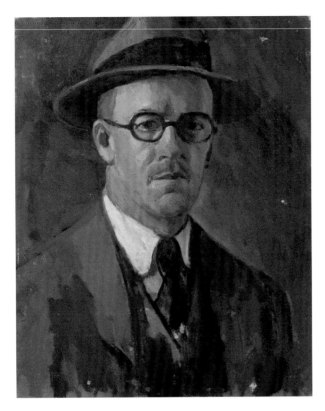

Figure 15
WALTER F. ISAACS
Self-Portrait with Hat and Horn Rims, 1936
Oil on canvas
22 x 18
Walter F. Isaacs Estate
University of Washington

1980) and Viola Hansen Patterson (1898–1984), another former UW art student who had been hired to teach upon graduation. Viola had been a student of Patterson's, whom she married in 1948. It seems clear that there was a lively semi-collegial atmosphere for Abrams to participate in, and within which to conduct her independent study projects once she had been accepted into the department and squared away her divisional requirements.

Sydney Abrams, whom she married in August 1948, five months after their first date, was an undergraduate student in history. He had just returned to Seattle after serving as a volunteer for the Hagannah's Organization for Clandestine Immigration (Mossad le-Aliyah Bet), carrying survivors to Palestine through the British naval blockade. These experiences are chronicled in a book by the captain of Sydney's ship, the SS *Paducah* in which Sydney Abrams is mentioned extensively.[8] Imprisoned for two months on Cyprus by the British once the ship was captured, Abrams was genuinely sensitive to what Marika Frank had undergone

and deeply moved by her pluck at surviving. In a parallel way she felt attracted to him because of his willingness to help other survivors whose dilemma she might have shared.

It may have been the stability of her relationship with Sydney that freed the young survivor to do something she had hitherto avoided: making art that alluded to the Holocaust. For whatever reasons, figurative imagery began to appear in student works like the lithograph *Interior* (Figure 13), of 1950, with its seated and standing female nudes. Faceless and defenseless, they pose before a long staircase leading to a darkened area beneath a curved arch. Could it be, as Selz suggests in his Preface, the aperture of the crematorium? It may also be significant that, years later, she acquired from the Isaacs estate *Two Figures* (1963) (Figure 16), ghostlike, faceless women emerging from a darkened background. Were they perhaps her mother and aunt? Or herself and Vera?

In turn, these two works contrast with a Hungarian painting, *In the Valley* (ca. 1900) by Béla Iványi Grünwald (1867–1940) (Figure 17), which the artist may have seen in the Hungarian National Gallery in Budapest during her childhood. Here two women are seated with their backs to the viewer, completely at ease before the idyllic scene of a lake and hills in the distance.

Other early works gradually took on deeper, and perhaps more explicit, references. As would be the case with such artworks throughout her long career, they can be read or interpreted on more than one level. Part Northwest landscapes, part Central European nighttime scenes, they introduced significant symbols that would be seen repeatedly over the next decade: the moon, the cat, the forest, and an often unidentified, offstage source of heat and flames: the burning crematoria (*Cats and Moon*, 1952).

A pencil study exists for *When the Sun Goes Down, the Moon Comes Up: Cïca Mica, Huntress* (1952) (Figure 18). Ostensibly a painting made to eulogize a favorite family cat, Cïca Mica, the gridded-off drawing (shades of Léger and Brazeau) has at its center a predatory feline with a dead bird in its mouth (Figure 19). The painting (formerly known as *Abstract*, 1952) turns the moon into a searching spotlight. The flame-orange outlines of triangular metal structures could be guard towers within

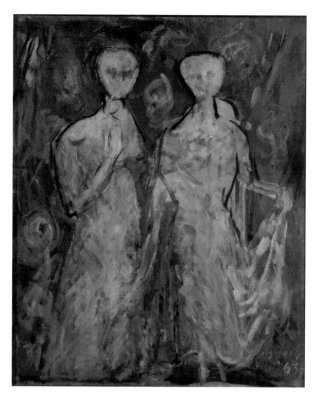

Figure 16
WALTER F. ISAACS
Two Figures, 1963
Oil on board
48 x 36

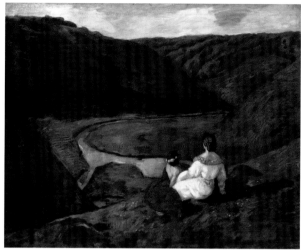

Figure 17
BÉLA IVÁNYI GRÜNWALD
In the Valley, ca. 1900
Oil on canvas
47 ¾ x 59 ½
Hungarian National Gallery, Budapest

the camps—or the familiar electrical towers of Seattle. The three towers seen in the distance above the cat could be seen from homes in the neighborhood where the Abramses first settled, Seattle's Madison Valley district—or barracks and supervisory structures at Auschwitz. A half-blood-red sun is incongruously glowing beside the moon. The overlapping curves of the grid enclose and entrap a composition that is only eluded by the ghostly white cat. Maria Frank Abrams had created a Holocaust painting that could not instantly be tagged—and thus dismissed—as such. She was making "poetry after Auschwitz" that was far from "barbaric," but in fact sensitive, symbolic, and haunting.

More poignantly and troubling, *Untitled (Crouching Figure)*, ca. 1953, presents an ambiguously gendered figure that is hiding in the forest holding in its hand a curved, scimitar-like knife, its blade poised toward the heart (figure 20). Beneath a crescent moon and with a barracks and watchtower in the distance, the crouching figure stretches the other arm over his or her head in a defensive pose. It could almost be a choreographic gesture—or a self-portrait. Abrams's only painted self-portrait (1956) places her in a Delaunay-like interior setting

of Cubist space with a comforting cat. It is a far cry from *Crouching Figure*.

Gradually, the darkness and tangled branches of forest thickets, guard towers, and ghostly cats were replaced by elements reflecting Abrams's discovery of her New World—Seattle and the landscape of the Pacific Northwest. Hundreds of scenes of mountains, lakes, and trees followed, usually filled with sunlight, but periodically darkened again. The bright would overshadow the dark for the most part, as the young student applied her knowledge of complementary colors and fractured Cubist space. Other modern art styles were tried out as well, including Surrealism and automatism, but eventually these were discarded as the artist approached a period of abstraction in the 1970s that was followed by the large, realistic landscapes of the 1980s, generally considered her greatest achievements in oil. Before those breakthroughs, however, Abrams's cultural education underwent further expansion.

It is unclear exactly how long Abrams's private instruction with Tobey in 1952 lasted; at most it was likely a few months of weekly lessons (Figure 21). Her shift to tempera and casein on paper was his most notable influence and one that continued for many years. His approach to abstraction was rooted in the natural world, and this too had a long-lasting effect on her. Most importantly, his introduction of her to his dealer, Otto Seligman, opened a world of exiled European musicians

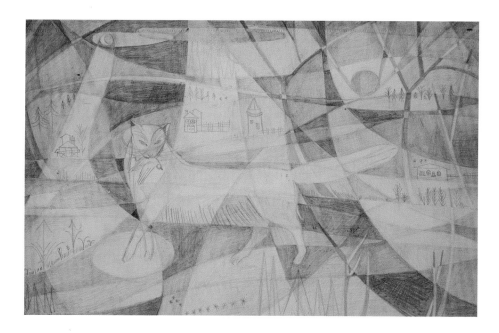

Figure 18
When the Sun Goes Down, the Moon Comes Up: Cïca Mica, Huntress, 1952.
Pencil on paper
8 x 10
Courtesy of Gordon Woodside / John Braseth Gallery

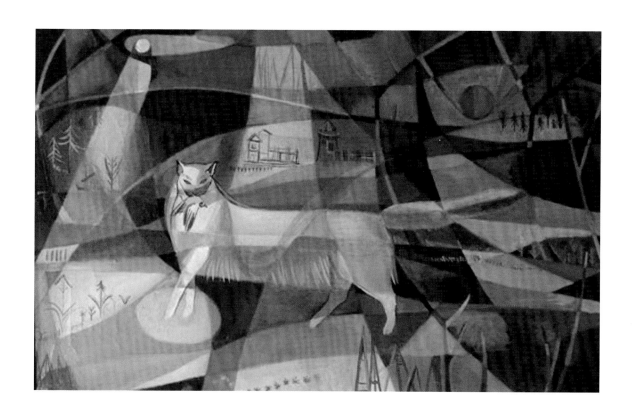

Figure 19
When the Sun Goes Down, the Moon Comes Up: Cïca Mica, Huntress, 1952.
Casein on paper
19 ½ x 30
Joan Hansen collection, Seattle

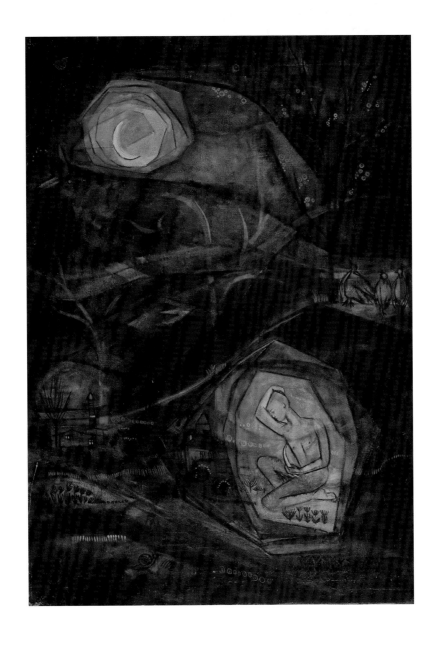

Figure 20
Untitled (Crouching Figure), 1953
Oil on canvas
28 ½ x 20
Courtesy of Gordon Woodside / John Braseth Gallery

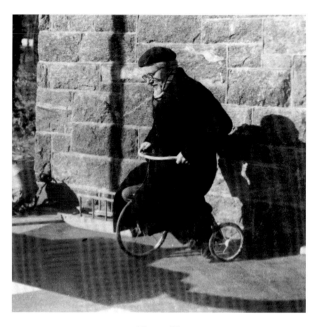

Figure 21
Mark Tobey on tricycle, Basel, Switzerland, ca. 1964

NOTES

[1] Shirley Tanzer, "Mrs. Marika Frank Abrams," William E. Weiner Oral History Library, American Jewish Committee Holocaust Survivor Project, January 15–16, 1976; February 10, 1976, III: 1-52.

[2] See Spencer Moseley and Gervais Reed, *Walter F. Isaacs: An Artist in America 1886–1964*. Seattle: University of Washington Press, 1982, 118–119.

[3] See Spencer Moseley, *Wendell Brazeau: A Search for Form*. Seattle: University of Washington Press, 1977.

[4] See Patricia Failing, et al., *Spencer Moseley: 50's–80's: A Retrospective Exhibition*. Seattle: Lynn McAllister Gallery, 1988.

[5] Undated letter from the Abrams archives.

[6] Shirley Tanzer, III: 1-62.

[7] Ibid.

[8] Capt. Rudolph W. Patzert, *Running the Palestine Blockade: The Last Voyage of the* Paducah. Annapolis, MD: Naval Institute Press, 1994, 22, 63, 132, 217, 200.

and intellectuals to both Maria and Sydney; it accentuated their mutual love of music and literature and began to repair the tear in her links to European culture that she had suffered as a result of World War II.

Newly naturalized in 1954, Maria Frank Abrams was about to become a European artist—for the first time. In time, all this activity meant return trips to Europe and even to Hungary. Until Seligman's death in 1966 and a shift of interest at his successor gallery, Francine Seders, Abrams would build her credentials as a postwar European artist living in America by closely observing the exhibitions of the Europeans Seligman brought to Seattle. These artists included Roger Bissière (1888–1964), François Stahly (1911–2006), Georges Mathieu (b. 1921), Maria Vieira da Silva (1908–1992), and a number of others including Tobey's partner Pehr Hallsten (1897–1965), a self-taught artist who was a graduate student in Scandinavian literature at the university. In this environment of sophisticated approaches to the nature of painting and the Tobey-induced reverence for painting nature, Maria Frank Abrams came into her own. It was as if she had to become a European artist before she could achieve her status as an American one.

Figure 22
Untitled, 1971
Oil on canvas
41 x 34 ½
Courtesy of Gordon Woodside / John Braseth Gallery

The Seligman Years

A Seligman Évek

Paul Klee (1879–1940), Lyonel Feininger (1871–1956), and Henri Michaux (1899–1984) were among the many postwar European artists whose work Maria Frank Abrams saw either at the Seattle Art Museum, the Charles and Emma Frye Art Museum, Seligman's gallery, or at the Zoe Dusanne Gallery, the city's first modern art gallery. It is not surprising that Maria Frank Abrams's initial exhibitions at Seligman's had the look of these artists, at once meticulous, linear, and gestural. She was undertaking her own Master of Fine Arts degree without attending the university's program (gradually formed chiefly to credentialize teachers), and by turning herself into a modern artist by assimilating their work and dialoging with them.

Tobey's influence remained paramount. Technique, materials, subject matter—and even, to a certain degree, content—were all carefully and studiously adapted from the Wisconsin-born artist, thirty-five years her senior. After his purchase of her print, *They Hold His Arms Up Until the Sun Sets Down—Exodus* (1952), Tobey bought a second impression as a gift for a friend, Eva Heinitz (1907–2001), a cello and viola da gamba teacher at the University of Washington School of Music. Professor

Heinitz became a friend of the Abramses. One invitation led to another and, as central members of the Seligman set, the attractive young woman and her engaging husband were soon befriended by other musician teachers on the faculty; the Swiss-born concert pianist Berthe Poncy Jacobson (1894–1975) who was also Tobey's piano teacher; and the Hungarian piano recitalist Béla Siki (b. 1923), an interpreter of Bartók, and his Swiss wife, Yolande, among others. The friendships had an important impact on Abrams's artistic evolution. Patterns, like those in musical compositions, formed the initial structures of her first abstract paintings (Figure 23). Whether indebted to Bach or Bartók, undulating patterns were increasingly punctuated by irregular, syncopated markings and shifts from dark to light. And with her preference for using Tobey's preferred opaque, water-based paints and pigments transparency was replaced by intersecting colored lines, either in weblike formats or curving, yarnlike skeins (Figure 22).

Other acquaintances in the Seligman circle had transitioned from an earlier salon, that of Seattle's first modern art dealer, Zoe Dusanne (1884–1972), an African-American woman from New York who was

Figure 23
Growth #9, 1957
Casein and ink on paper
13 ½ x 25

Tobey's first Seattle dealer. She courageously displayed and championed art by postwar Japanese-American artists as well, including George Tsutakawa (1910–1997) and Paul Horiuchi (1906–1999). Tobey's move from her gallery to Seligman (Figure 24), who had opened a space in the Wilsonian Hotel in the University District at Tobey's suggestion, effectively wrecked her business; she never recovered after losing Tobey's clients, and subsequently lost her Roland Terry–designed home / gallery to the building of the Interstate-5 Highway the year before the World's Fair opened.[1]

Travels in Europe in 1965 and thereafter made possible Abrams's cautious reconnection to European civilization. Having referred to Hungary as a "cemetery," she nevertheless returned several times in the coming years to help an aging aunt. Trying out the styles of one artist after another helped Abrams find a signature style of her own at a time when a "look" seemed de rigueur for success in Seattle. She had seen how it worked for Tobey and his erstwhile protégé, Morris Graves (1910–2001), who had parleyed Tobey's "white writing" technique into something resembling bird droppings on a lichen-covered rock. The trouble was that Marika Abrams was already thirty. She had not entered college until she was twenty-three, and was now married with an infant son to raise. She had yet to find any signature style or look. She had been too busy dealing with her past in her paintings after leaving the university. Thus far, they were her most original works, yet hardly the stuff of sellout shows in 1960s Seattle.

Over the ensuing decade, the period culminating in Century 21, the 1962 Seattle World's Fair, Abrams's profile rose substantially. She did eventually find her own look: delicately linear nature studies with her own type of Tobeyesque white writing, though one more suggestive of masses of black pine needles than calligraphic strokes (*Pines*, 1970) (Figure 25). Before that, besides exhibiting regularly at Seligman's, she was repeatedly included in all the juried annuals and seemed headed for anointed Northwest

Figure 24
Otto Seligman, 1961

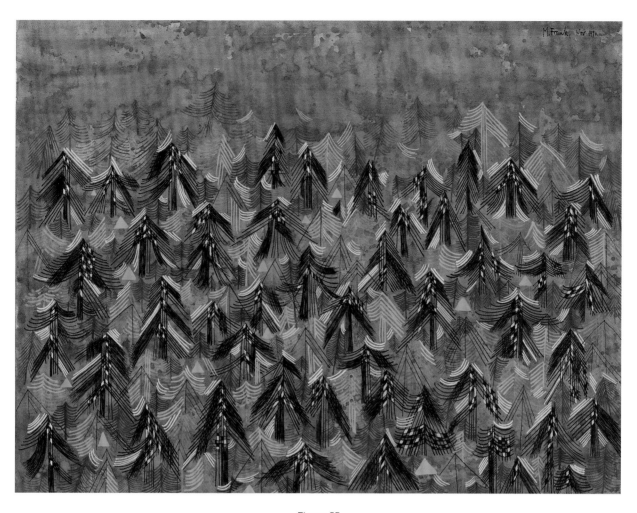

Figure 25
Pines, 1970
Casein, pen and ink on paper
11 x 14 ¼
Gift of the artist
Jundt Art Museum, Gonzaga University, Spokane, Washington

School status. This was confirmed in 1957 when, before acquiring her *Winding Forest* (1959) for the Seattle Art Museum from works included in the *Eighteenth Annual Exhibition of Northwest Watercolors*, director Richard E. Fuller (1897–1976) offered her a one-person exhibition at the museum in 1957. She had been in America less than a decade. It was the first of three subsequent art museum surveys of her work, the second being at the Seattle Art Museum in 1966, and the third at the Nordic Heritage Museum in 2002.

At the same time, Abrams was also becoming a public figure. She cosigned and helped script letters objecting to a Chi Omega sorority alumni newsletter attacking the UW faculty for its ostensible communism and disloyalty,[2] and condemning the author, Mrs. V. D. Lowry,[3] who had attacked Abrams's close friend Giovanni Costigan (1905–1990), a noted liberal professor at the university and biographer of Sigmund Freud.[4] Newspaper coverage, letters to the editor, and a concession by the sorority that sponsored an annual "art tea" that the artists initially boycotted added up to a lively controversy. Abrams and her friends in Artists Equity were at its center.[5]

Other artists from Europe who ended up in Seattle and with whom Abrams formed friendships included Manfred Lindenberger (1914–2008), a painter from Germany who had also been a private Tobey pupil, and Lisel Salzer (1905–2005), an Austrian refugee who specialized in commissioned enamel portraits and who, like Abrams, had exhibited both at the Seattle Art Museum and the Charles and Emma Frye Art Museum, a more conservative institution that was nonetheless remarkably pluralistic and tolerant in its annual juried *West Coast Exhibition of Painting*.

Working prolifically first in a small studio in their new home designed by architects John and Audrey Van Horn and later in a larger studio (designed by Larry Cross) added in 1981, Abrams found that she had not completely left behind the darker skies and visions of her post-baccalaureate years—nor would she ever completely do so. Instead, woodland enclosures, groves, and "coppices," a word she used in the title of one work, were joined by more open meadows, lawns, and yards, as well as scenes from public parks in Seattle and on Mercer Island. Dense city skylines appeared, complementing contrasting scenes of suburban serenity. Her Seligman exhibitions tended to be stylistically varied, especially once she began her swirling, linear series of paintings, attempts at Surrealism, and her space-splintering landscapes such as *The Hounds of Spring Are on Winter's Traces* (1970) (Figure 26). Sometimes, unidentified ghostly figures would reappear, as in *Untitled (The Visitor)* (1954) (Figure 27), which raised the specter of the unwelcome Holocaust survivor, come back like an avenging angel to haunt nighttime urban neighborhoods. The visitor figure seemed to insist on remembrance, respect, and recognition. It may have been an alter ego for the artist. Among other darker scenes of increasing formal complexity, *Our Valley* (ca. 1953) and *Night Walk* (Figure 28), of 1960 depict hillside habitations seen through impassible thickets of entangling undergrowth.

Although Arthur Hall Smith only knew Abrams during a brief, two-year period when he lived in Seattle, he retains vivid impressions of her and her art between 1954 and 1956. "I'd arrived in Seattle on the GI Bill after the Korean War to study with Tobey and so, through him, I met the whole Seligman crowd," Smith mentioned in a telephone interview from his home in Paris,

> They were divided in half: Half the Old World and half the New. And there was Maria right in the middle. [Seligman] had these open houses at his apartment in the Wilsonian [Hotel] on Thursday evenings and everyone, especially musicians like [choral conductor] Miriam Terry, [piano teacher] Elsie Geismar, [composer] Lockrem Johnson, and [artist and flutist] Windsor Utley [1920–1989], was there,

Smith continued. "As to her art," he added,

> she prefigured all-over patterns—but with leaves. I don't know, but she may have also picked this up from Trudi Hershman, a textile artist. . . . Maria had many strings to her bow. She knew what Otto's gallery represented and she would pitch her own work, but Maria never calculated.[6]

In a typical, somewhat condescending review of her 1961 solo show at Seligman's, *Seattle Times* art critic Anne G. Todd commented, "Even though Mrs. Abrams is a mother, she also considers herself a painter." This was qualified by Todd's prefatory remarks that Abrams's work "refuted the cliché idea that bright women art students who get married are never heard from again." Todd points to her early impression of Abrams's "feminine fantasy . . . derived from themes and modes of music . . . light and lyrical . . . delicate and precise . . . slender and vernal." Strangely, she ended the review by praising the thirty-seven-year-old for "slackening the perfectionism that can be the scourge of the very young."[7]

While she was not selected by curator Millard B. Rogers for the big World's Fair art show, *Northwest Art Today*,[8] out of eighty-six artists, there were only ten women, all older than Abrams. However, on the occasion of the six-month-long exposition (April 21 to October 21, 1962), Seligman wrote and published his own catalogue, *Northwest Artists of the Seligman Gallery*, highlighting the nineteen regional artists he represented.[9] In his introduction, Seligman credits Tobey with developing his eye for art after a childhood and youth spent in the art museums of Vienna and Paris. Each artist is represented by a full-page black-and-white illustration of his or her work (*Untitled Drawing*, 1961, in Abrams's case) (Figure 29) and a formal photographic portrait.

About Abrams, Seligman perfunctorily mentions the German concentration camps and then comments about the way

> [t]he Pacific Northwest has proved to be a sympathetic environment for Mrs. Abrams, evoking youthful memories of a satisfying past. She finds this an inspiring place in which

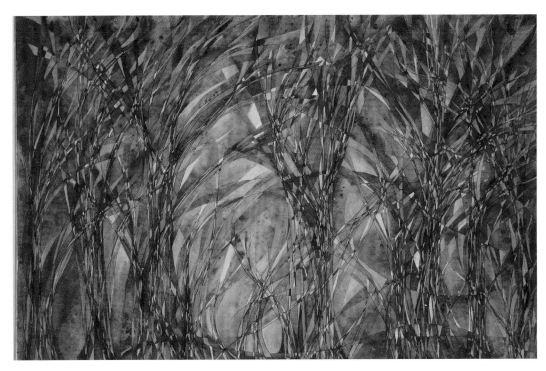

Figure 26
The Hounds of Spring Are on Winter's Traces, 1970
Casein, ink, and wash on paper
18 x 27 ¼
Henry Art Gallery, University of Washington 2008.215

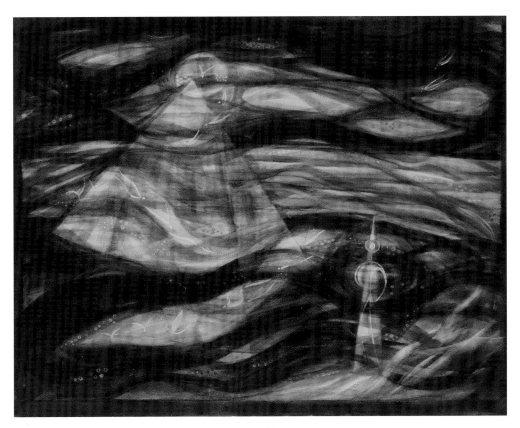

Figure 27
Untitled (The Visitor), 1954
Casein and ink on paper
23 x 29
Courtesy of Gordon Woodside / John Braseth Gallery

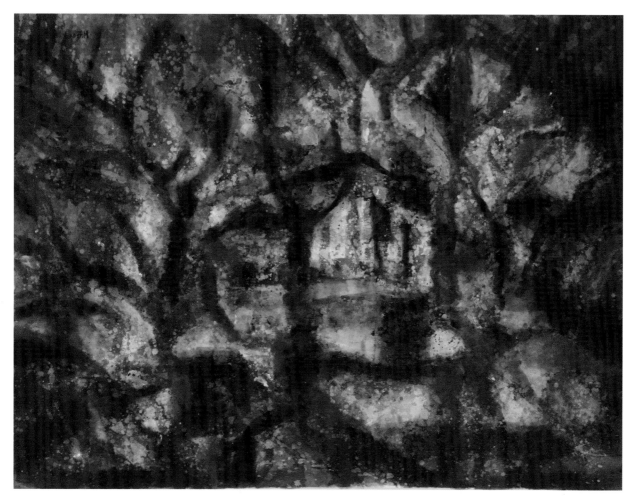

Figure 28
Night Walk, 1960
Casein on paper
23 ½ x 28 ½

to pursue her artistic quest for a deeper understanding of man's relationship to nature and the universe.[10]

It is uncertain whether Seligman had seen the darker paintings of the 1952–56 period. At any rate, these are passed over in favor of her Tobeyesque "relationship to nature and the universe."

Not content with merely showing borrowed works on consignment from his European friends, Seligman had a local stable that had, as Abrams did, considerable international connections of their own. Jacob Elshin

(1892–1976) was from St. Petersburg; Fay Chong (1912–1973) came from Canton, China; Pehr Hallsten was from Sweden; Lisel Salzer from Austria; and Herbert Siebner (1925–2003) from Germany. Ensconced in the city's top gallery, Abrams was perfectly poised for her next professional step: to become a public artist, mosaicist, and muralist. In the process, she created some of her most important works, substantially expanded her studio activities beyond painting, and prepared once again to cope with memories that would not go away.

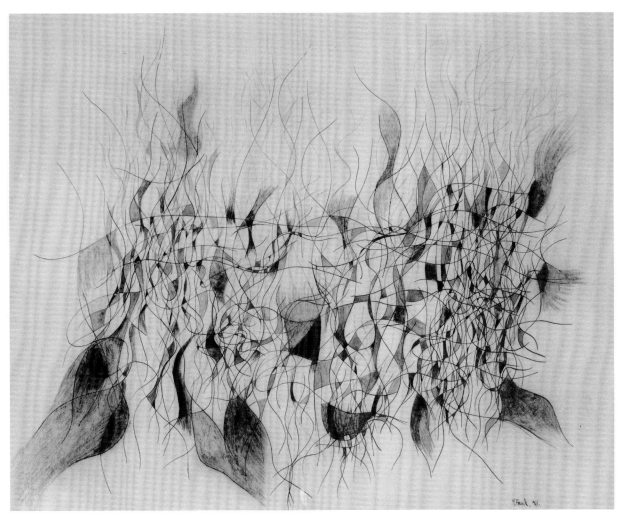

Figure 29
Untitled Drawing, 1961
Ink and mixed media on paper
8 x 10
Location unknown

NOTES

[1] See my "Merchants, Mavens, and Modernism: A History of Seattle Art Dealers," in *Relocations: Selected Art Essays and Interviews.* New York: Midmarch Arts Press, 2008, 80–81.

[2] Barry Farrell, "For Criticism of Professors: Artists Boycott Sorority Exhibit at U. of Wash," *Seattle Post-Intelligencer*, March 21, 1961, I.

[3] Mrs. V. D. Lowry, "Operation Abolition," *Chi Omega Newsletter*, March 1961.

[4] Giovanni Costigan, *Sigmund Freud: A Short Biography*. New York: Macmillan, 1965. He was also the author of *Makers of Modern England: A Chronicle / The Force of Individual Genius in History*. New York: Macmillan, 1967.

[5] "Art Wins: Chi Omega Collectors Tea," *Seattle Post-Intelligencer*, March 24, 1961, 9.

[6] Arthur Hall Smith, telephone interview with author, July 26, 2008.

[7] Anne G. Todd, "Women's Art Refutes Cliché Idea," *Seattle Times*, April 16, 1961, S11.

[8] Millard B. Rogers and Gervais Reed, *Northwest Art Today / Adventures in Art*. Seattle: Century 21 Exposition, Inc., 1962.

[9] Otto Seligman, *Northwest Artists of the Seligman Gallery*. Seattle: Otto Seligman Gallery, 1962, unpaginated. The other artists featured were Guy Irving Anderson, Dorothy Barbee, Fay Chong, Jacob Elshin, Jean Elshin, Richard Kirsten, Mary Lou Kuhl, Thelma Lehmann, James Martin, Elizabeth B. Michkils, Carl Morris, Hilda Morris, June Nye, Pehr Hallsten, Lisel Salzer, Herbert Siebner, Mark Tobey and Windsor Utley.

[10] Ibid.

Figure 30
Costume design for Leah in *The Dybbuk*, 1963
Ink and casein on paper
Approximately 12 ½ x 10 ½
Tobin Collection of Theatre Arts, McNay Art Museum, San Antonio, Texas

CHAPTER THREE

Public Artist

Közismert Művész

> Maria has painted some exceptionally good murals for Seattle Town and
> Country Club's walls, a redecorating job that ends its birth throes Friday
> night. They're of Seattle scenes—the totem pole in Pioneer Square, the
> Aurora Bridge, the Locks, the Smith Tower. There are 10 of them, and
> people who know art think they're worth talking about.
> — Sally Raleigh, *Seattle Post-Intelligencer*, May 25, 1961[1]

Thanks to Walter F. Isaacs, Abrams's dean and mentor at the School of Art, she was recommended for two murals, one at the Town and Country Club, a private dining facility at Ninth and Union in downtown Seattle, and the other surrounding an indoor swimming pool in a private home on Portage Bay. Although both are now destroyed, they represent her debut as a public artist. In time, she would build on her earlier efforts at mosaics, and extend her vision to other murals, scenic designs, and costumes. Everything came together in the King County Arts Commission honors award of 1976, when she was commissioned to execute her design for a mural at the Mercer Island Public Library, not far from her home. (The mural is still extant, though it was damaged, repaired, and then reinstalled poorly in another area of the library at the time of a renovation in 1995.)

While the early murals gave her a chance to expand the scale of her work somewhat, they also offered a new prospect for a shift in subject matter from the somber scenes of the early 1950s to more light-filled city scenes and, eventually, to the abstraction she deemed appropriate for public settings. One advantage to abstract artworks in the public domain is that viewers can generate their own meanings, thus reinforcing democratic cultural values without recourse to popular culture sources. Instead of asking "What does it mean?" the viewer may say, "Here's what it looks like to me," a better option than the old cliché "My child could do that."

It was the husband-and-wife architect team, John and Audrey Van Horn, who initially suggested that Abrams create a mosaic for the exterior of the home they were designing for the Abramses in 1957 on West Mercer Way. Abrams decided that the freestanding living-room wall that contained the fireplace was the best location for it. Her study, *Be Gentle as the Dove and Wise as the Snake* (1958), may reveal a small blue bird in flight in the final 3 by 9 foot completed mosaic (Figure 31). The abstracted, undulating path of the snake is also present. The mosaic reveals in part her Bauhaus-style training at the university—all art forms are equal—along with her classes in grid-based design, which in turn may have been influenced by Léger's methods for public-scale paintings.

Another precedent is the mosaic work of the Hungarian Art Nouveau artist, Miksa Róth (1865–1944). Hungary's greatest mosaic and stained-glass artist, he

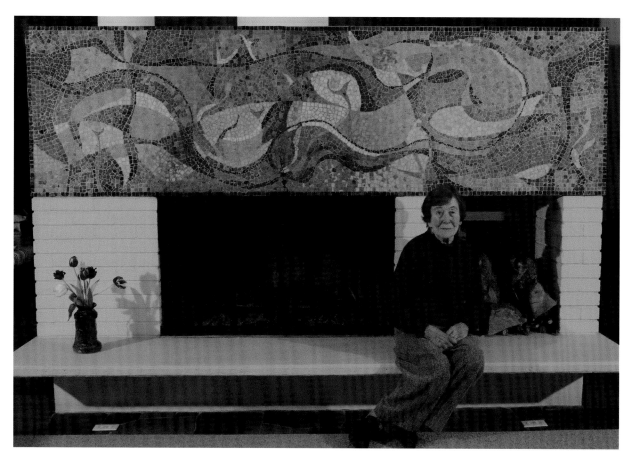

Figure 31
Be Gentle as the Dove and Wise as the Snake, 1958
Glass mosaic
36 x 156

executed widely praised public projects in Budapest, including work at the Academy of Applied Arts. It is unlikely Abrams saw these works despite her periodic visits to the capital with her parents before 1944, but she may have when she returned to Budapest briefly in 1945 after the war. Even so, Róth's *Rising Sun* (1900) (Figure 32), like the fireplace mosaic, also uses stylized natural forms, undulating lines, and a composition that fills its entire space. Unlike Róth, Abrams avoided clearly identifiable representation and used a more subdued palette. Another 1958 mosaic study for an outdoor mural has attenuated floral stems, as in *Rising Sun*. However, it went unbuilt, as did a final mosaic, *Waterfront* (1977), meant for an undetermined site at Seattle Center, on the grounds of the 1962 world's fair. Interestingly, it was at the new Seattle Center Playhouse, another spin-off of the fair's architecture, where Abrams's next foray into public art, costume, and set design, would premiere in 1963.

It is important to note the influence of the mosaic and mural designs on Abrams's later art. First, they mark an advance in the artist's development as a modernist, grounded in her combination of Paris atelier and Bauhaus design background at the university. And in addition, increasing degrees of abstraction may be observed, from the perfectly distributed curvilinear forms in *Be Gentle as the Dove . . .* through the stricter, more geometric interpretations of *The Four Seasons* (1976), the library mural.

When approached in 1961 by Norman Israel, the producer of *The Dybbuk*, a new opera by composer Michael White with a libretto by George Bluestone, Abrams

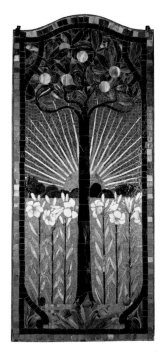

Figure 32
MIKSA RÓTH
Rising Sun, 1900
Murano and Tiffany glass mosaic
with gold leaf by Puhl and
Wagner
40 ¼ x 30 ⅛
Miksa Róth Memorial House,
Budapest 99.49.1

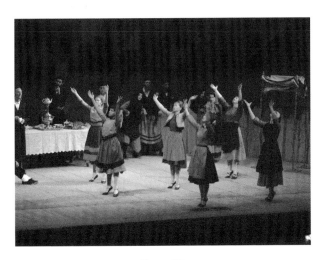

Figure 33
Dance for Leah, Act II, *The Dybbuk*, performance view,
January 5, 1963, Seattle Center Playhouse

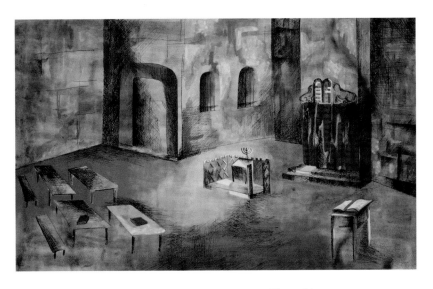

Figure 34
Interior of synagogue, Act III, Scene 2, *The Dybbuk*,
preliminary study for set design, 1962
Casein and ink on paper
10 ½ x 12 ½
Tobin Collection of Theatre Arts, McNay Art Museum,
San Antonio, Texas

Figure 35
Scene design for Act III of *The Dybbuk*, 1962
Watercolor, gouache, and ink on paper
13 ⁷⁄₈ x 22 1/2
Tobin Collection of Theatre Arts, McNay Art Museum,
Gift of Maria Frank Abrams and Sydney Abrams

47

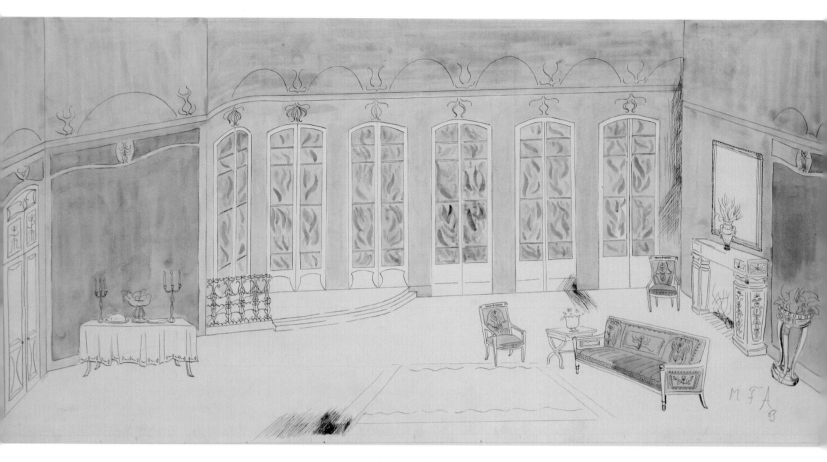

Figure 37
Scene design for Violetta's drawing room in *La Traviata*, 1963
Watercolor and ink on paper
14 x 28 ½
Collection of the McNay Art Museum,
Gift of Maria Frank Abrams and Sydney Abrams
TL2009.3.3

had to think twice before accepting his offer to do costume and set designs. On the one hand, she was the perfect artist for the job. Now, after all the fashion sketches she did during the period of her slave labor in Magdeburg, she could design and have real clothes constructed. It was a dream come true, in a way. From her childhood observations of village raiment in remote areas of Hungary and Czechoslovakia while on summer vacations with her family, she knew how such costumes should look. On the other hand, diving into the project might raise dark specters and memories of unpleasant events. Accepting Israel's importuning, she designed over twenty costumes and sets for three acts with five scenes (Figure 36).

The plot required more than peasant clothes. In addition to the village women, whose outfits had to be loose enough to dance in, the prospective bridegroom wears fancy city clothes that are ridiculed by the villagers. The prospective bride, Leah, after a visit to her mother's and former boyfriend's graves, returns to reject her foppish fiancé in an arranged marriage and is pronounced possessed—a dybbuk—by the dead boyfriend's spirit. In Act III, an exorcism is performed in the synagogue and Leah falls dead, at last reunited with her original lover in death.

With its music conducted by Stanley Chapple (1900–1987), the British director of the University of Washington's School of Music who had performed extensively at Covent Garden and in Europe, both the score of the opera and its production received glowing reviews, and it has subsequently been revived across the United States (Figure 33). Abrams was assisted in the painting and construction of the sets and costumes by a crew of twenty-two people. The director was another university faculty member, Gregory Falls (1922–1997), head of the professional actors' training program and founder of the city's first professional summer stock company, A Contemporary Theatre.

Figure 36
Costume design for Hannah in *The World of Sholom Aleichem*, 1963
Ink and colored pencil on paper
13 7/8 x 8 1/2
Collection of the McNay Art Museum
Gift of Maria Frank Abrams and Sydney Abrams
TL2009.4.6

The graveyard scene must have been acutely meaningful for Abrams since her own first boyfriend, Pál Vági (1920–1943), had also died prematurely, incinerated when Hungarian soldiers set fire to a makeshift quarantine in the Ukraine where hundreds of Jewish labor servicemen were being held.[2]

Seattle Post-Intelligencer art critic Thelma Lehmann (1916–2007) pointed out how the designs (Figures 34 and 35) were "conceived in purely abstract terms. . . . In the courtyard set . . . the backdrop . . . moves into the distance by means of a neighborhood of subtly painted cubist houses."[3]

A few months later, the forty-year-old artist was approached to design sets and costumes for the first pro-

duction by the new Seattle Opera company, *La Traviata* (The Lost One), of 1853, Giuseppe Verdi's opera based on the Alexandre Dumas play, *La dame aux camélias* (1852). Reunited with Norman Israel, Abrams faced a greater challenge with *La Traviata*, one that involved seventy painted flats as well as staircases, a bed, a fireplace, and "enough furniture for a villa."[4] Once again, critics were favorably disposed toward Abrams's work, which was praised by UW poetry professor David Wagoner in his *Seattle Times* review.[5] When the curtain went up and the set was exposed, the audience burst into applause (Figure 37).

Abrams's final theatrical undertaking, costumes for *The World of Sholom Aleichem* by Arnold Perl, was presented in 1981 by the short-lived Jewish Theatre Company at the Jewish Community Center on Mercer Island and for one performance in Seattle at Temple De Hirsch Sinai. Here Abrams was on familiar ground again. The shtetl inhabitants' costumes were brightly colored, conveying the appearance of the lavish embroidery Abrams had seen on peasant clothing as a child in Hungary and Czechoslovakia. In contrast to *The Dybbuk*, the stories of Sholom Aleichem (1859–1916), the basis for the Broadway musical *Fiddler on the Roof* (1971), were permeated with warmth and affectionate humor.

With successive solo exhibitions at a variety of galleries in Seattle and throughout the Pacific Northwest region, Abrams was building a substantial career. Some reviews and profiles even omitted mention of the Holocaust experiences. M. Frank had become Maria Frank Abrams. Building on Dr. Fuller's acquisition of *Winding Forest* (1959), the Seattle Art Museum offered another show in 1966 and received gifts of other artworks of hers including *Organic* (1959) (Plate 12) from collectors Anne and Sidney Gerber. Other museums as well as an increasing number of public and corporate collections also obtained examples of her work.

Stylistically, Abrams kept her bases loaded, ready at any time for a prospective home run. When she was named one of the first four King County Arts Commission honors award recipients, in 1976, she was easily able to design and execute *The Four Seasons* (1976), a site-related work installed at the Mercer Island Public Library. Apart from being the purest expression of Abrams's abstract style, it presaged an entire decade's worth of work

Figure 38
The Four Seasons, 1976
Oil on canvas
48 x 348
Mercer Island Public Library, Mercer Island, Washington
King County 4Culture Collection of Art

in that vein, the geometric landscapes, discussed in greater detail in Chapter Five. In the library mural, Abrams executed her largest work, leaving open the question of the direction her art might have taken had she continued to blend a kind of color-coded imagery with such extreme size. For whatever reasons, Abrams was not to attempt this scale or degree of abstraction for another decade (Figure 38).

Loosely distinguished, from left to right, in sections of spring, summer, fall, and winter, *The Four Seasons* was the perfect complement to the rectilinear structures of the library's architecture. Like the books on the shelves beneath it, the 29-foot-wide painting contained upright vertical forms that could be read as books on a shelf, but that also scanned as a series of light and dark forms suffused with what appeared to be the equivalent of natural daylight (the mural was illuminated from below and above by its own electrical lighting).

While Abrams remained active in seeking later,

larger public commissions for civic buildings, the library mural (as it was originally viewed) remains her most important large work. The conversion to a greater degree of nonrepresentational subject matter, however, would be temporary. Refining the geometry and subtly contrasting palette of the library mural, Abrams simultaneously turned to more explicit landscape imagery in the subsequent decade and beyond. Return trips to Europe, including a visit to Debrecen in 1969, seemed to open up veins of reminiscence that came to coexist with her recognizable responses to the dramatic scenery of the Pacific Northwest.

Abrams was resistant to being confined to a single distinctive look by now; she had several at her disposal as a result of her maturing talent. Constantly working in her studio, she exercised a freedom to paint both abstractly and realistically. Light-filled summer scenes were accompanied by colder winter reveries. As always, skylines and forests contemplated by night kept reoccurring.

Viewed in the context of her travel to Europe, including taking care of family matters in Budapest, her darker paintings may be seen as the ongoing focus of coping with memory and loss. In one case in particular in Vancouver, British Columbia, the paintings captured the attention of another Holocaust survivor, one who, like the mysterious figure in *Untitled (The Visitor)* or the possessed Leah in *The Dybbuk*, demanded Abrams's attention before peacefully departing.

NOTES

[1] Sally Raleigh, "Murals Show Seattle Scene," *Seattle Post-Intelligencer*, May 25, 1961.

[2] Randolph L. Braham, *The Hungarian Labor Service System 1939–1945*. Boulder, CO: *East European Quarterly* 1977. Page 39 describes this ghastly atrocity.

[3] Thelma Lehmann, "Set Designer for 'The Dybbuk' Scores Well on First Assignment," *Seattle Post-Intelligencer*, January 8, 1963, 19.

[4] " 'La Traviata' Sets: Center Factory Builds Opera," *Seattle Times*, May 26, 1963.

[5] David Wagoner, "Verdi's 'La Traviata' Thrills a Near Capacity Audience at Opera House," *Seattle Times*, June 7, 1963.

Figure 39
Winter Sky with Leafless Trees, 1961
Oil on canvas
48 x 30
Collection of Edward Frank Abrams and Tali Bdolah-Abrams, Jerusalem

Return to Debrecen

Visszatérés Debrecenbe

Let me recite what history teaches. History teaches.
— Gertrude Stein, "If I Told Him: A Completed Portrait of Pablo Picasso"[1]

With her studio advances of the 1960s—larger scale, increasing abstraction, the scenic and costume designs—Maria Frank Abrams found herself at the forefront of Pacific Northwest artists. She retained her ties to Mark Tobey after he left Seattle in 1960 and visited him in Basel, Switzerland as late as 1971. Her numerous exhibitions included Portland, Oregon, and Vancouver, British Columbia, as well as regular appearances in the Seattle Art Museum's and Frye Art Museum's various juried annuals. Her role in the Chi Omega affair during the McCarthy era and her membership in Artists Equity ensured her continued public profile.

Media coverage of Abrams's art changed gradually. In place of each article or review being largely preoccupied with probing for Holocaust anecdotes, interviews and feature stories devoted roughly half to retelling her World War II experiences and half to inquiries and observations about her art, working methods and inspirations.

In "Paint a Song of Happiness," *Seattle Post-Intelligencer* reporter Gail Olson captured a prescient comment by the artist who had already addressed indirectly in earlier works some of her terrifying experiences as a teenager in the war: "Some day, as I go on, I hope to be able to express the suffering through my painting. I want to show what losing my family was like. I want to show what it is to be completely alone" (Figure 40).[2]

Did this ever occur? In my opinion, no. It could be that the enormity of the horrors precluded Abrams from taking on what she professed to want in the 1967 interview. On the other hand, after return trips to Hungary in 1969, thirty-five years after the deportations, and ten later trips through 1998, Abrams may have developed other artistic methods that opened up different, more bearable veins of memory: cloudy or nighttime landscapes; nearly total geometric abstraction; and the return of the figure. These directions did not evade the expression of suffering, but they sidestepped explicit imagery and never returned to the smoldering forest scenes, such as *Cats and Moon* (1952), that she depicted soon after leaving the university.

In the Olson interview, Abrams mentions in passing her inspiration from the music of Hungarian composer Béla Bartók (1881–1945) and Hungarian poetry: "My poets are Hungarian. . . . I read them in Hungarian. They are the poets I read while growing up."[3]

Figure 40
Former Jewish ghetto, Debrecen, Hungary, 2009

in *Music for Strings, Percussion, and Celesta* (1936) and *String Quartet No. 6* (1939), eerie sounds filled with premonitions of horror and dread. Similarly, we know the young Marika Frank read the great Romantic Hungarian poets of the early and middle nineteenth century such as Endre Ady (1877–1919) and Mihály Csokonai Vitéz (1773–1805), the latter of whom wrote, in "The Night and the Stars"

My bright and gleamy scope of being
Has turn'd to frightfully horrid darkness.[4]

or Ady, whom she quoted to Tanzer, as well as another poet, Mihály Vörösmarty (1800–1855), who wrote, in "The Death of a Small Child":

One thinks of Bartók's moody, dissonant orchestral writing of the 1930s or his "night music" passages

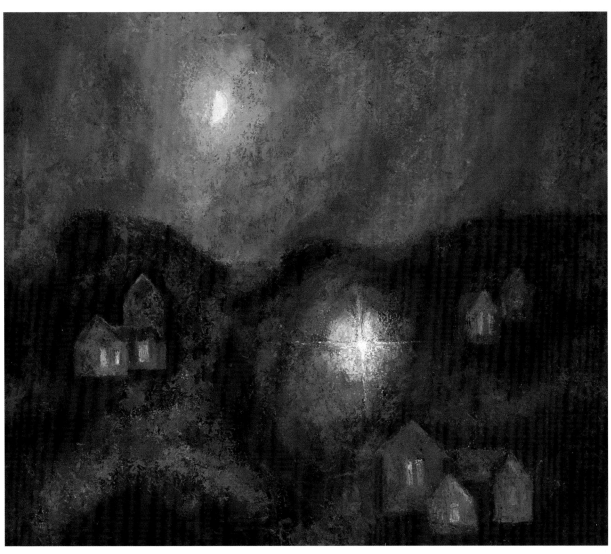

Figure 41
Moon and Streetlight, 1954
Oil on canvas
26 x 32
Collection of Steve and Esther Rotella, New York

When in clear and cloudless silky nights
The stars come out and float on the expanse,
Oh, will you come to bless your forlorn
 parents?
Oh, will you come by midnights to bring
 them dreams?[5]

While not offering precise analogies to her paintings of the period and later ones such as (Figure 41) *Moon and Streetlight* (1954) and *Winter Sky and Leafless Trees* (1986), such poems suggest how poetry and—by extension—painting can evoke approximate melancholy moods and acknowledge death and darkness.

Dark skies, looming clouds, starry nights, ominous nighttime forests, moonlit environments empty of people, are all among the motifs that reoccur throughout Abrams's oeuvre and that return in force in the realistic oils and landscapes of the 1970s and 1980s after Abrams's return trips to Hungary. She often remarked that her own parents had no graves of their own for her to visit, and this was a source of great sadness to her. Visiting the Jewish Cemetery in Debrecen in 1969 and again in 1976, 1982, 1992, and 1998 (Figure 42), may have been the trigger for a number of paintings, including *Electric Night* (1978), whose title is shared with a Tobey painting of 1944 (Figures 43 and 44). The shapes in the Tobey are dark, urban structures outlined in his characteristic white writing, with an open door or coffin at their base containing a figure. Abrams's title refers to a starless and seemingly moonless urban skyline with upright trapezoidal structures at its base. Her visits to the Jewish Cemetery in Debrecen exposed her to the upright, very tall shapes of the memorial headstones. Thus, a Seattle cityscape is transformed in *Electric Night* into a combination of past and present, Seattle and Debrecen, tokens of the living and dead. With their irregular positioning in loose rows, the outlined, irregular four- and six-sided polygons stand in as tombstones, reminders of the dead ever present in the artist's memory whether in Hungary or America. Their forms could also suggest coffins. Employing modernism's strategies of dislocation and distortion, Abrams has (unconsciously or otherwise) managed to "express suffering," as she would continue to do so indirectly for the next decade in her paintings.

Returning to Debrecen in 1969 would not have been easy. At that time, she met with a gentleman, Féri (József) Szábo, who as a youth working in her father's store had volunteered to accompany her young cousin, Lajos Rózsa (b. 1928—now Lewis Rose of Sydney, Australia) in a clandestine effort to leave the Debrecen ghetto and travel by train to Budapest where he could be hidden by his father's gentile fiancée and thus avoid deportation.[6] The reunion with Féri, a "righteous gentile" who knew and loved Abrams's father and acted courageously to smuggle her cousin to safety, may have been one factor contributing to an evolution in Abrams's dealing with a past so utterly destroyed through and with the active collaboration of Hungarians.

Two men whom she did not meet or know in Debrecen (both were still in Israel in 1969), but who returned to Debrecen first after 1945 and then, after 1989, permanently, offer parallel memories of the events of World War II in Marika Frank's hometown. Tibor Fischer and Sándor Garamvölgyi told the author in interviews at the Jewish Community Center that they remembered the Frank family and Mr. Frank's men's clothing store.

Garamvölgyi also lost his parents at Auschwitz, but unlike Marika Frank he did not learn of their deaths until he returned home after the war. He had been in a Russian prisoner of war camp. He received no regrets or apologies from former neighbors and friends in Debrecen, "None," he recalled, "but we never thought that would come from Hungarians."[7]

The train on which Tibor Fischer was in en route to Auschwitz (the train Marika Frank's father had declined to take in favor of a later and, unbeknownst to him, fatally prompt one) was rerouted due to a bombing of bridges by Russian forces. He ended up in Austria instead. Eventually, after being put on another train, one headed for the Russian Front where he would presumably dig trenches, Fischer jumped off and hid in a farmer's attic that was twice sprayed with machine gun fire, first by German soldiers, and then by Red Army conscripts.

Reunited with his parents in Debrecen after the war, remarkably, Fischer found that his family's home and grocery store had been returned to them. As Fischer related, "I went to Israel, but my parents started from

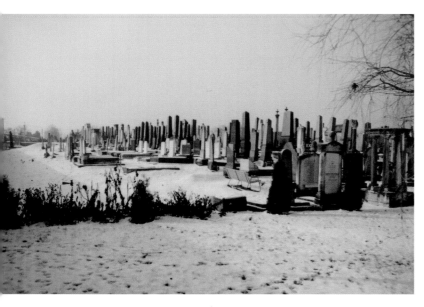

scratch again and built up the business."[8] His mother had attended the same high school, Gymnasium Dóci Leány, as Marika Frank had.

Abrams's "return" to her past in Hungary stands out in relief against the stories of these two fellow survivors of her generation who reconciled themselves with renewing their lives in Hungary and actually returned to live in the city of their birth. There was no similar reconciliation for Abrams, but rather a new willingness and desire to incorporate aspects of her past in her artistic vision.

Besides the examples of folk-embroidery patterns with their bright colors and intricate lines, other forms of art also had their long-term impact on the formation of Marika Frank's sensibility, both as a child artist and as Maria Frank Abrams. These textile works were on view in Debrecen's only art museum, the Déri, which

Figure 42
Jewish Cemetery, Debrecen, Hungary, 2009

Figure 43
Electric Night, 1978
Casein and ink on paper
28 ½ x 36 ½

Figure 44
MARK TOBEY
Electric Night, 1944
Tempera on paper mounted on board
17 ½ x 13
Eugene Fuller Memorial Collection, Seattle Art Museum

realistic detail—*Christ Before Pilate*, *Golgotha*, and, astonishingly, an *Ecce Homo*—while the sufferings of Debrecen's Jews are not even mentioned in the museum's local history exhibit covering the years 1361 to 1945.

Even as she was traveling regularly to Europe, beginning with her first trip in 1965 and continuing till her final journey to Debrecen in 1998, Abrams pursued an active studio life. She easily found other galleries in Seattle to exhibit in after leaving Seligman's successor, Francine Seders, in 1967. These included the Kirsten Gallery and Janet Huston Gallery. One dealer in Vancouver, British Columbia, Estika Hunnings of the Canvas Shack (later

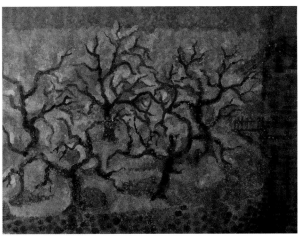

Figure 45
Ancient Orchards, 1966
Casein on paper
18 x 24
Location unknown

opened in 1930. Originally the Municipal Museum founded in 1902, the institution moved into a new building, the Déri Museum, after a wealthy silk manufacturer, Frigyes Déri (1852–1924), donated his extensive fine-art collection that also included numerous examples of Egyptian and Asian art. Marika Frank would also have seen the eighteenth- and nineteenth-century Hungarian landscape paintings on view. Works by Gyula Benczúr (1844–1920) and László Paál (1846–1879), as well as Károly Kernstock (1873–1940) (Figure 46), especially, foreshadow Abrams's calm Northwest landscapes of spring and summer scenes (Figure 45). The museum is also filled with treasures from Turkey, Iran, and Japan, along with an important collection of folk art from the surrounding Carpathian Basin area that arrived in 1938.

The centerpiece of the Déri collection is a giant triptych, *The Christ Trilogy* (1881–96), by Mihály Munkácsy (1844–1900), Hungary's most celebrated artist. Ironically, the sufferings of Christ are depicted in

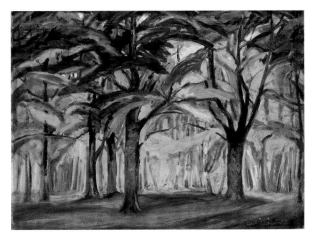

Figure 46
KÁROLY KERNSTOCK
Autumn Light (In the Forest), 1922
Oil on cardboard
28 x 39 ⅓
Hungarian National Gallery, Budapest

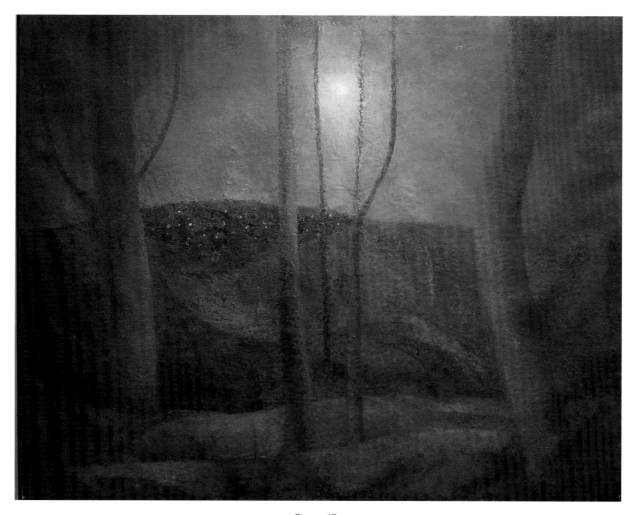

Figure 47
In the Calm of the Night, 1967
Oil on canvas
36 x 48
Estate of Mrs. Sam Heller, Vancouver, BC, Canada

Canvas Gallery), proved to be a crucial contact. Originally from Zagreb, Yugoslavia, Mrs. Hunnings had married an Englishman and emigrated with him to Canada via Egypt. She gave Abrams two solo shows and included her in a number of group shows. Her connections gave the artist access to important collectors in Vancouver. *In the Calm of the Night* (1967), acquired by Mr. and Mrs. Sam Heller, is a good example of her work at this time (Figure 47).

It was during her 1967 exhibition that another Holocaust survivor, Margaret Sebestyen, contacted Abrams shortly before her opening after reading about her upcoming exhibition. They had been together at Bergen-Belsen and Magdeburg. Perhaps not surprisingly, the reunion was picked up by reporters in *The Province*[9] and *The Vancouver Sun*[10] and mentioned prominently in a short series of articles and editorials that again played up the Anne Frank coincidence. Abrams pointed out in

several interviews that she had learned only later that Anne Frank had also been in the same barracks tent at Bergen-Belsen with her, but that Anne was a woman she never met or knew, and to whose family she was not in any way related.[11] Despite her eventual joyful meeting with Margaret Sebestyen, Abrams was disappointed that the local newspapers had chosen to focus on her personal history and not her art.

However, with Vancouver's large Jewish population, which included a greater number of Holocaust survivors than in Seattle, interest in such matters was considerable. Further emigrations from Hungary in 1956 at the time of the unsuccessful revolution expanded the exile community both in Vancouver and western Canada, many of whom were absorbed by the tale of the two survivors' reunion. The lesson of history, as Gertrude Stein pointed out, was often the very awareness that the past could instruct the present.

NOTES

[1] Gertrude Stein, in *Selected Writings of Gertrude Stein*. New York: Modern Library, 1961.

[2] Gail Olson, "Paint a Song of Happiness," *Seattle Post-Intelligencer*, January 6, 1967.

[3] Ibid.

[4] Mihály Csokonai Vitéz, in Otto Tomschey, ed. *Hungarian Poets of the Eighteenth and Nineteenth Centuries: A Selection*. Budapest, Hungary: Madách Irodalmi Társaság, 2004, 185.

[5] Mihály Vörösmarty, in Tomschey, *Hungarian Poets*, 157.

[6] Edward Abrams, e-mail communication to author, February 26, 2009. Abrams recounts how her cousin was saved at page 14 of the transcript of the interview with Janice Englehart for the Shoah Institute of December 8, 1995.

[7] Sándor Garamvölgyi, interview with author, Debrecen, Hungary, January 19, 2009.

[8] Tibor Fischer, interview with author, Debrecen, Hungary, January 19, 2009. Although Fischer believed that the bombing of bridges sent his train back, and Abrams also credited bombing the tracks with preventing the first transport from reaching Auschwitz, historians maintain that the rerouting of two transports from Debrecen was the result of an agreement by the SS to supply needed labor to the area around Vienna, and may also have been intended to serve as a bargaining chip in negotiations. Yehudah Bauer, *Jews for Sale? Nazi-Jewish Negotiations 1933–1945*. New Haven and London: Yale University Press, 1994, 201; and Randolph L. Braham, *The Politics of Genocide: The Holocaust in Hungary*. Rev. ed. New York: Columbia University Press, 1994, 723–724, 734–736.

[9] Stuart Gray, "She Was with Anne Frank," *The* (Vancouver, BC) *Province*, February 15, 1967, 25.

[10] Ann Barling, " 'Emotional' Reunion Arranged," *The Vancouver* (BC) *Sun*, February 16, 1967, 36.

[11] Shirley Tanzer, "Mrs. Marika Frank Abrams," William E. Weiner Oral History Library, American Jewish Committee Holocaust Survivor Project, January 15–16, 1976, II: 1-71.

Figure 48
Cool Land—Warm Sky, 1983
Casein on paper
38 ½ x 28 ½
Gift of Sydney Abrams and Maria Frank Abrams
Museum of Northwest Art 08.208.50

CHAPTER FIVE

The Geometric Landscape

A Geometriai Tájkép

Over time, the topography of Pacific Northwest art history has changed. Maria Frank Abrams now appears as a transitional figure. Beginning as a Tobey protégée and second-generation Northwest School artist, she rejected Tobey's and Graves's pseudo-spiritual aspirations as a goal for art and over the next few decades developed into an artist whose vision seemed to orient itself midway between the naturalistic formalism of Tobey and the more severe abstraction of such younger university moderns as Brazeau, Moseley, and Francis Celentano, an optical perceptualist who joined the UW faculty in 1965.

This chapter will explore the complex interface between representation and abstraction in Abrams's middle and late periods. The works in the 1965–85 period also contained realistic oils on canvas, yet, and more significantly, other paintings that veered increasingly toward total abstraction. How did this transformation come about and, more importantly, was it one that precluded the artist's consideration of her horrific experiences during in World War II?

One would think that a destination of nonrepresentation in her paintings would offer a haven away from unpleasant memories and nightmare events, perhaps favoring the hedonistic escape routes of pure color, form, and surface texture. Put another way, Abrams's arrival at a form of geometric landscape seems at first glance to be a transcendence of painful memory and loss. However, this would be an oversimplification if not an error. As they developed, the shapes, forms, and lines that dominate the geometric landscapes blend with aspects of color, hue, and tone into something much more nuanced and complex.

All this was balanced with Abrams's roles as wife and mother to Sydney and Edward. A larger studio, designed by Larry Cross of Omni Design, was added to the Mercer Island house in 1981 and, in addition to providing space for increased production, it offered generous access to natural daylight along with vertical storage racks for works the artist chose to retain in her personal collection. Both the ample daylight and the sight of the vertical storage racks may have had an influence on the artist's new abstract imagery.

Just as her early student works may be read on more than one level, so it is with the geometric landscapes. Usually possessing horizon lines in their upper or lower third, such paintings emit and radiate sunlight

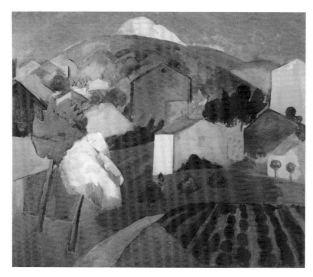

Figure 49
WALTER F. ISAACS
Landscape Composition, 1931
Oil on canvas
60 x 72
Gift of Mrs. Sidney Gerber
Henry Art Gallery, University of Washington 67.8

or, alternately, are suffused with the darkness of an indeterminate deep space. Traces of landscape and its attendant moods of weather and light, however, are present in many of the works, not only in the realistic landscapes done in a parallel time span. Especially when they make use of casein or tempera on paper, they often allude to a Northwest climate and, as such, connect to Tobey or Graves or even Kenneth Callahan (1906–1986), whose later abstract paintings adopted and adapted imagery suggestive of wind currents and storms.

Nevertheless, some of Abrams's pictures bear little or no resemblance to landscape or climate and, in turn, nudge closer to the hard-edge sensibilities of Moseley and Brazeau, both of whom were influenced by their colleague Celentano. In Abrams's case, even at her most nonrepresentational, there are still hints of interpretable subject matter and whiffs of historical content that lead

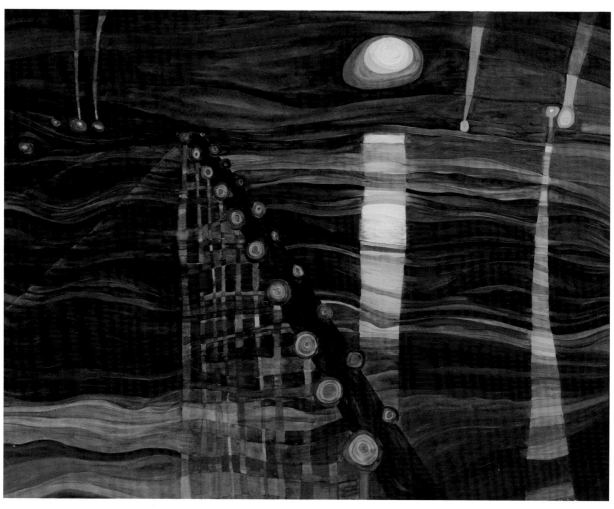

Figure 50
Untitled (Floating Bridge), 1951
Casein on paper
22 ½ x 28 ½
Arthur and Alice Siegal Collection

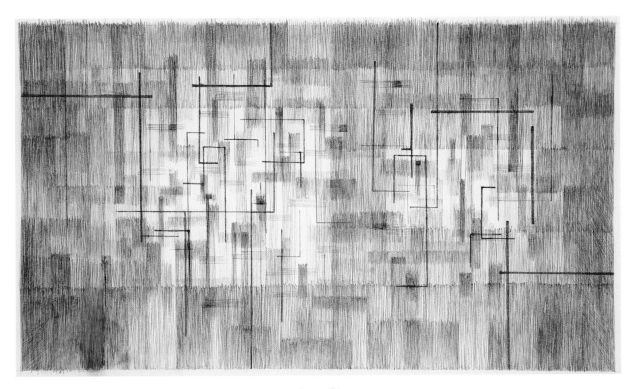

Figure 51
Untitled (Gray and Blue Blocks), 1955
Casein and ink on paper
14 x 25 ¼
Courtesy of Gordon Woodside / John Braseth Gallery

one back to the retrieval of memory and expression of loss.

Walter F. Isaacs's *Landscape Composition* (1931) (Figure 49) is a touchstone for Abrams and other contemporary university moderns. With its carefully placed polygons, triangles, and squares, Isaacs's picture showed the way local subject matter could find a way beyond regionalism and into modernism. Composition—as in placement, positioning, and distribution of pictorial elements—was Isaacs's strong point and a lesson Abrams learned well. Perhaps set in eastern Washington or the Yakima and Chelan valleys so favored for vacations by the university moderns, *Landscape Composition* captures both the sylvan perfection of the area and its Cézannesque devolution into "the cylinder, the sphere, the cone, everything in proper perspective so that each side of an object or a plane is directed toward a central point," as the Frenchman put it.[1]

With this Isaacs work as a backdrop, an examination of Abrams's oeuvre suggests that before the geometric landscape there was the geometric cityscape. In *Untitled (Floating Bridge)*, of 1951 (Figure 50), oncoming traffic on the new Mercer Island floating-pontoon bridge connecting the island to Seattle is geometricized into triangles, haloed circles, and vertical streams of white and blue. It was the twenty-seven-year-old artist's first fully abstract painting, completed during her senior year. Over the ensuing decade, and created simultaneously with the paintings and prints that alluded to the Holocaust, other paintings like *Untitled (Gray and Blue Blocks)*, of 1955 (Figure 51), *Untitled (Stick Figures in Grid)* of 1959, and *Ramp* (1961) reflected the rise of Seattle's urban core. *Ramp* shows the entrance and exit sections of downtown highways under construction as overlays on a gleaming nighttime skyline. Haunting and tightly structured like other works of this period, Abrams's urbanscapes were gradually joined by imagery that still retained architectural hints, as in *Untitled (Beach Fences)* of 1966, but that inhabited spaces that were more open and airy.

Abrams's experiments in automatism, a dimension of Surrealism that turned to the private language of seemingly random, unconscious squiggles, were still highly controlled and balanced. *Untitled (Organic Abstraction)* of 1966 comes close to Callahan's expressions of coastal wind currents, but with a wider palette of blue

Figure 52
Flowering Vines, 1961
Casein on paper
28 x 22
Location unknown

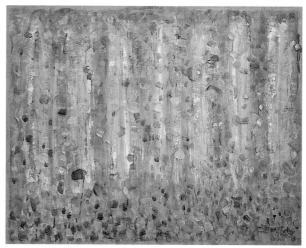

Figure 53
MARK TOBEY
Golden Gardens, 1956
Tempera on panel on panel
35 ¼ x 44 ¾
Roland P. Murdock Collection, Wichita Art Museum M159.60

and green, orange, yellow, and red. *Cool Land—Warm Sky* (1986) regulates its weather conditions with stricter divisions of line and color.

In addition, in works like *Flowering Vines* (1961), (Figure 52) the Hungarian-born artist met Tobey on his own "white writing" ground. When compared to the older artist's *Golden Gardens* (1956, Figure 53)—the title refers to a Puget Sound public beach near the Ballard area of Seattle where Tobey lived with his partner Pehr Hallsten for a time—*Flowering Vines* straddles representation and abstraction more openly. Despite its title, Abrams's painting is largely abstract, with an all-over composition, a palette of orange and gold, white and black, and a bustling, ascending movement that shimmers. Each artist was seeing the other's work at Seligman's and, while Tobey's influence on Abrams—water-based media, natural imagery, and curving, gestural marks—is often remarked upon, it is also possible that Tobey's wider and more varied palette in these years, as in *Golden Gardens*, may have been affected by his exposure to the younger artist's brighter palette and her more exuberant execution and example.

Two companion works, *The Heart of the Night* (1983) and *Nocturne* (1986) (Figure 54), propose another aspect of Abrams's work, at her closest to the more "mystical" aspects of Graves and Tobey. Each has a central, elongated oval area that both advances and recedes from surrounding darker sections composed of interlocking squares and rectangles. Unlike the hazy haloes often present in Northwest School paintings (e.g., Leo Kenney), Abrams's world is organized and structured. Reflecting the necessity of spiritual discipline before the awareness of ecstatic revelation, the geometric compositions of both paintings are what provide dramatic contrast for the lighter-colored emanations within each work. Executed in casein, a water-based pigment that favors dark over light, *The Heart of the Night* and *Nocturne* offer a sense of evening devotional focus. They represent high points within the artist's output, as she pushed the Northwest School toward greater formal rigor. With their distant lineage of Mondrian's squares and grids, they also bring Northwest art closer to Europe and mark Abrams as the key transitional figure between regionalism and European modernism.

In Tobey's wake, Abrams remained the one artist who assimilated his teachings and brought them closer to more advanced developments in the American art of the 1960s and 1970s. The pulsating light that emerges from the center of each work illuminates these paintings as potential spaces for mystical experiences grounded in contemplation and meditation. Yet their shared shim-

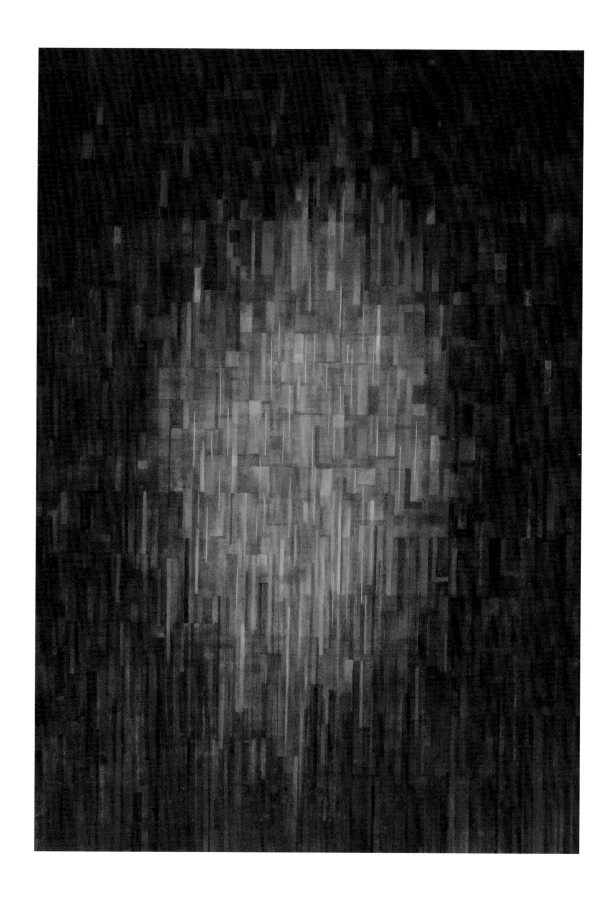

Figure 54
Nocturne, 1986
Casein on paper
36 x 25 ¾
Courtesy of Gordon Woodside / John Braseth Gallery

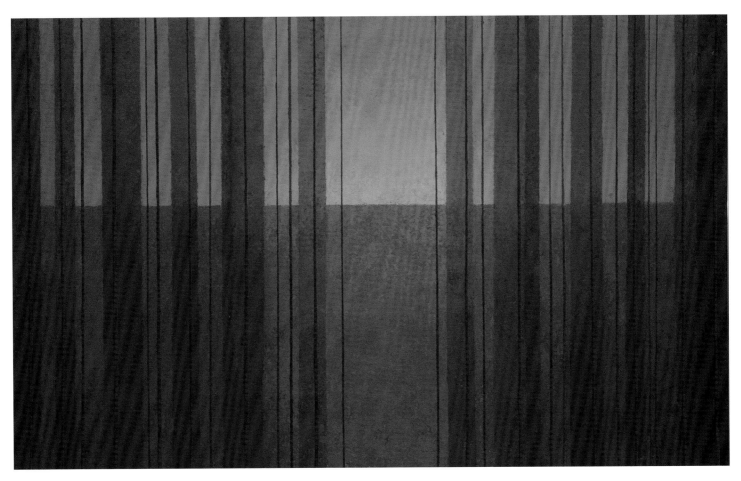

Figure 55
Untitled (Red and Gray Lines), 1986
Oil on canvas
48 x 96
Courtesy of Gordon Woodside / John Braseth Gallery

mering grids of contrastingly cool (*The Heart of the Night*) and warm (*Nocturne*) colors rein in any such ecstatic events, hinting at revelation, but restricting it to an ordered and unified world.

Finally, ending on a darker note, Abrams's summation of her geometric landscape series, *Untitled (Red and Gray Lines)* of 1986 (Figure 55) recapitulates memories that had been tamped down in the preceding paintings within the series. On the surface, the four-by-eight-foot oil on canvas is large and expansive, enveloping the viewer in a wraparound panorama of two wide bands of dark and light gray that are bisected by twelve light and dark gray posts that are themselves overlaid with twenty-six thin red lines. With its simple but forceful bands and reductive color scheme, *Red and Gray Lines* appears to be one of the artist's responses to the Op Art of the university moderns, Brazeau and Moseley, but especially Celentano, whose huge *Reversible Units II* (1968, Figure 56) was displayed at the Henry Art Gallery.

If the viewer approaches the painting in the light of *The Heat of the Night* and *Nocturne*, it may be seen as a field for meditation and contemplation, too. Moreover, in evading the rigid systems of Celentano's High Op period, Abrams leaves telltale signs of the real world. The horizontal bands suggest the desolate land beyond Auschwitz. The lighter gray area at the top, with its faint, eerie glow, suggests the sky—of freedom. The vertical, postlike shapes comprise a barrier of sorts, a fence, or a series of concrete columns. With such an interpretation, the geometric landscape proves its utility as a vehicle for dealing with the Holocaust. Thus, the vivid red lines are streams of blood. Ordered and organized yet uneven and not strictly regular or asymmetrical, the painting is an apotheosis of the artist's evolution from representation to nearly complete abstraction. One further metaphor is possible in interpreting *Red and Gray Lines*. The filled-up bottom two-thirds of the composition has a somewhat rough, painterly texture in contrast to the smoother

Figure 56
FRANCIS CELENTANO
Reversible Units II, 1968
Acrylic on canvas
60 x 120
Courtesy of the artist Laura Russo Gallery

vertical areas. Could this area that weights down the overall image be the accumulation of ashes from the crematoria?

In one work, Abrams has encapsulated the formal advances of the prior three decades, beginning in Isaacs's classes and then blended with the residual memories of loss and absence. Those who argue against the possibility of such content existing within abstract art need only examine the early works of the New York School to discover unexpected interpretations of the paintings of Arshile Gorky (1905–1948), Adolph Gottlieb (1903–1974), and Robert Motherwell (1915–1991). In their work, as in Abrams's, it is possible to recognize philosophical, historical, and even political analogies.[2] The contextual difference for Abrams lies in the fact that she has, like the early Abstract Expressionists, retained abstraction's right to address profound themes such as memory, death, and evil, and has done so largely without the numinous spiritual pretensions of the Tobey group.

Maria Frank Abrams secularized the art of the Northwest School, carrying it into the latter quarter of the twentieth century, modernizing it beyond regionalism and occult spiritualism. With the increased scale of her work reaching beyond Tobey's intimate size, she helped the Northwest School face down and equal the achievements of the New York School. And, as we shall see, she did all this without forsaking representation, a brighter palette, or an imagery of nature rooted in hope and growth.

NOTES

[1] Paul Cézanne, in Herschel B. Chipp, ed., *Theories of Modern Art: A Source Book by Artists and Critics.* Berkeley, CA: University of California Press, 1968, 19.

[2] Robert Carleton Hobbs and Gail Levin, *Abstract Expressionism: The Formative Years.* New York: Whitney Museum of American Art, 1978.

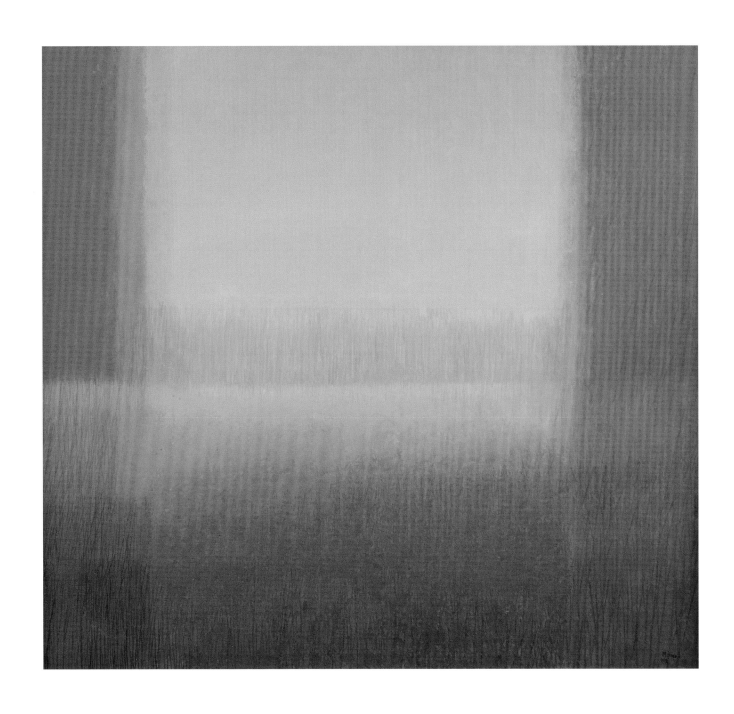

Figure 57
Beyond Summer's Fields, 1978
Oil on canvas
46 x 50
Joseph E. and Ofelia Gallo collection, Modesto, California

CHAPTER SIX

Time Regained

Az Idő Visszanyerése

Painting to me is living. I paint very naturally. I have never been able to incorporate my
survivor experiences into my work. I failed every time I tried.
. . . Painters paint because they see things . . . very intensely. Everything I see affects my
creative imagination. I always have a definite idea of what I want to paint. . . . My Holocaust
experiences have not given me visual inspiration. I receive my visual inspiration from living in
the Northwest.

When I look back over my work I see the same shapes, the same compositions, the same
structure, redone, reworked, superficially different but actually the same. I paint from a very
basic personality and that's what I've got for better or worse.
— M. F. A., 1981[1]

The above comments come as close as possible to an artist's credo for Maria Frank Abrams. Considering that she participated in eight formal oral history and print-media interviews over the course of a lifetime, Abrams's comments have been largely focused on her World War II experiences and, within those parameters, her comments on her art generally have, as above, played down or dismissed links between the Holocaust and her art. However, as I have tried to demonstrate in this book, these experiences had both short-term and long-term unintended influences on the appearance of her art. Such an interpretation may fly in the face of the artist's lengthy disclaimers, but it is evident when one looks closely and attentively at the paintings, prints, and drawings themselves.

So it is also with the question of the influence of Hungarian art and culture on this naturalized American's art. There are no traces of acknowledgment in her

interviews of Hungarian art history other than her frequently repeated disparagement of the level of art education in the schools in Debrecen she attended, reducing it to the copying of peasant folk embroidery patterns. Nevertheless, my research in the U.S. and during a 2009 trip to Hungary uncovered substantial evidence of similarities between Abrams's landscapes and the long tradition of Hungarian landscape painting, including such artists as Gyula Benczúr, Károly Kernstock (Figure 46), László Mednyanszky (1852–1919) (Figure 59), and László Paál, whose works Abrams may have seen at the Hungarian National Gallery in Budapest or at the Déri Museum in Debrecen prior to 1944. She shares with them forest scenes, individual trees in landscapes, sunrises and sunsets, seasonal shifts as subjects, and a flair for painting clouds, leaves, and horizons.

It has been my intention to not so much restore a Hungarian context and background to Abrams's art as

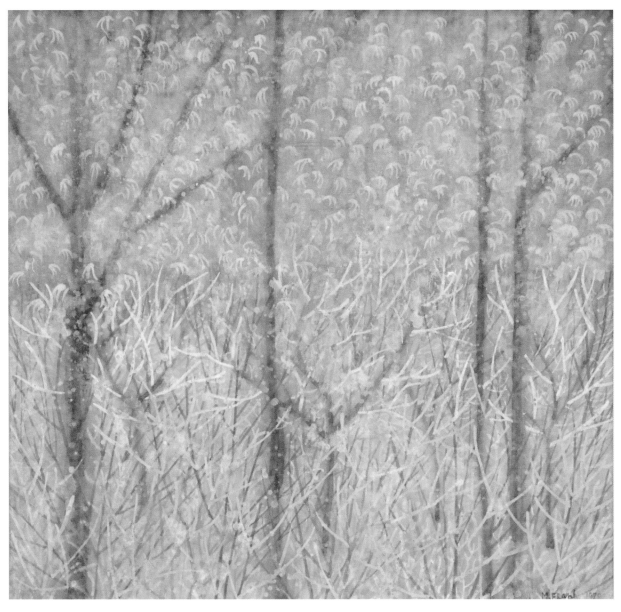

Figure 58
Spring, 1975
Casein on paper
18 x 18
Joanne Perri collection, King City, Oregon

to create a structure of historical context where none existed before. Similarly, my imposition of Holocaust-related interpretations has been undertaken less with any wish to refute Abrams's denials or demurrals of such links than with the desire to supplement and amplify her remarks, offering doubts or questions about her repeated comments, based only on the visual evidence I have found in the paintings. When the artist notes how her inspiration has been evoked by the nature of the Pacific Northwest, I have tried to explain how this proved to be a bi-level construction, perhaps even a plinth upon which to rest memories of dread and foreboding sum-

moned up by the landscape, all cloaked in the parallel phenomena of cloudy weather, dark skies, and nighttime scenes.

Early paintings such as *Cats and Moon* (1952), with its burning forest, were followed by more explicit paintings and drawings like *Sorrow* (1957), *Keeper of Graves* (1964), and *The Parting* and *Remembrances* (both 1966). *The Parting* (in the collection of the Yad Vashem Holocaust Art Museum in Israel) depicts the artist's mother, aunts, and young cousin at the moment they were separated from her in the "selection" in Auschwitz; yet here too the narrative of selection, separation, gassing, and

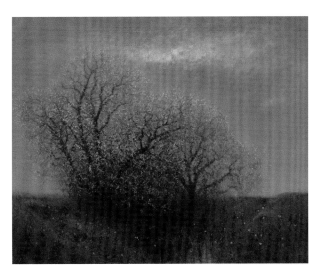

Figure 59
LÁSZLÓ MEDNYÁNSZKY
Trees in Bloom, ca. 1895
Oil on canvas
74 ¾ x 95 ⅔
Ferenc Mora Museum, Szeged, Hungary

crematoria is evoked obliquely by the smoke-like washes, the vertical posts that could be tree trunks or posts of a fenced barrier, and the barely suggested darkness into which the figures recede. These are not the failures Abrams may have believed them to be but significant works of art that deal symbolically and allegorically with the events of World War II.

That said, it is necessary to stress the candor of Abrams's other remarks above about her seeing "the same shapes . . . compositions . . . structure, redone, reworked . . . different, but actually the same." This, too, may be inaccurate or overstated. Despite the reiteration of themes—light and dark, winter and summer, warm and cold, lake and shore, earth and sky, valley and mountains—that is readily apparent as one examines her lifetime's work, it is equally important to note the variety of materials and techniques: the prints, paintings, drawings, murals, mosaics, set and costume designs; the oils, acrylics, caseins, and watercolors. In this sense, the work of the later years illustrates both the breadth of subject matter and the depth of her material mastery. Abstraction and representation blur in works of greater scale and brighter color. Hopeful, optimistic daytime scenes outnumber brooding nocturnal views.

Beyond Summer's Fields (1978) may still have an enclosing perimeter, but its inviting green meadow and distant pink glow present a liberating vista. It recalls the artist's comment in an untitled 1983 address about

April 11, 1945, the day of liberation at Magdeburg by U.S. soldiers:

> It was wondrous to be free, to be in the world once again, to be on Earth having come out of Hell. To see green grass, trees in bud, to look up at the sky, at the clouds which suddenly were so clean, so fresh! In the camp even the sky seemed filthy, defiled, threatening.[2]

Contrastingly, *Autumn Forest* (1987) (Figure 60) retains the inner emanation of *The Heart of the Night* (1983) and *Nocturne* (1986), but expresses an even brighter, larger central area of access. Within another reading, one closer to Abrams's view of herself as an apostle of Northwest nature with an affinity to the poetic "mysticism" of Tobey and Graves, it is worth recalling, in light of *Autumn Forest*, the words of the great Northwest poet of the period, Theodore Roethke (1908–1963):

> It was beginning winter,
> An in-between time,
> The landscape still partly brown:
> The bones of weeds kept swinging in the
> wind,
> Above the blue snow.[3]

Other paintings of the 1980s express comparably chilly yet comforting sentiments. Scenes of Luther Burbank Park on Mercer Island, such as *Autumnal Eve* of 1985 and *Winter's Moon* (1987), are directly evocative of local scenery and veer farthest away from the memories of 1944–45. They prove that the artist was unquestionably inspired by the forests, evergreen throughout falls and winters, and by the lakes and rivers that seldom freeze. In its surrounding of trees on an island in the middle of the 24-mile-long Lake Washington, Abrams's studio is permeated by light and air that glistens with moisture. *The Olympics* (1988), *Winter Twilight* (1995), and *Sunlight and Shade* (1999) (Figure 61) also evoke the peculiar regional climate phenomenon of simultaneous sunlight and rain. Brightness and darkness within the same picture is another theme in the later work.

This balanced condition of rain and sun, darkness

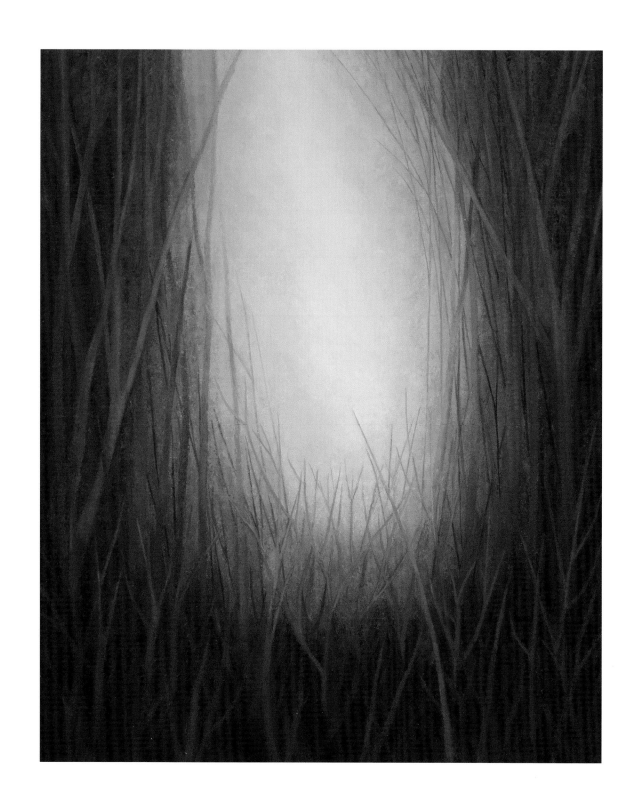

Figure 60
Autumn Forest, 1987
Oil on canvas
45 x 53 ¾
Olga and Henry Butler Collection

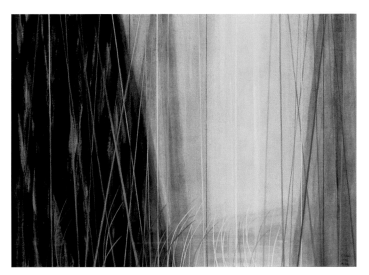

Figure 61
Sunlight and Shade, 1999
Oil on canvas
30 ½ x 40
Location unknown

and light, is also a description of Abrams's own life, aware of the extreme sadness that still colored great happiness and yet occasionally, as in *Receding Horizons* (1983) and *Summer Leaves* (1995), escaping it.

A solo exhibition (Figure 62) at an artist-cooperative space in Budapest in 1994 went some distance toward repairing the bad feeling between Abrams and her native country. With the fall of communism in 1989, such issues as the fate of Hungary's Jews and the Horthy government's complicity could be aired more openly. The artist's visits to the central European nation began in 1969 and ended in 1998. She undertook them in part to help an aging aunt, Kató Rózsa Csanak (1906–1991) who was ailing. During one of these visits, Abrams visited A Vizualart Galeria, spoke with its members, and was offered an exhibition. Consisting of several dozen paintings, the exhibition was well attended and warmly received by those who came to the opening. A review by the Hungarian art historian and stage designer, György Szegő, was published in the quarterly journal *Mult és Jövö* (Past and Future). Szegő, himself the son of survivors, observed that Abrams's abstract paintings "say the opposite" of Adorno's dictum on art after Auschwitz.[4]

This was a healing activity that was equaled in 2001 when the artist was selected by Richard V. West, director of the Charles and Emma Frye Art Museum, for a four-person companion show[5] at the same time as

the touring exhibition, *Witness & Legacy: Contemporary Art About the Holocaust*.[6] Interestingly, Abrams was a guest lecturer at the time as part of the museum's related educational activities. She discussed the fiftieth anniversary of her liberation from Magdeburg and repeated a version of the talk at a convention of Holocaust scholars held in Seattle in 1996.[7]

The artist had begun speaking publicly about such events in 1976 when the then University of Washington professor Deborah E. Lipstadt invited her to meet and answer questions from students. As she told Englehart:

> I was called upon a number of times to speak to history classes and a few times to classes who took the Literature of the Holocaust [course]. A few times I was asked to speak in high schools and I find that I can speak to a class which has been studying the period and is well prepared quite easily. . . . But I don't like to talk to groups . . . that are unprepared.[8]

(Lipstadt goes into greater detail in her Foreword to this book.)

Between trips to Hungary and important visits with her husband, Sydney, to visit her son, Edward, in Israel in 1980, 1984, 1986, and annually from 1989 until 2002, the depth of Abrams's perspective on the pain and suffering of 1944–45 grew. This enabled her to rise to the occasion when invited by Nordic Heritage Museum director Marianne Forsblad to have a survey of her work at the museum in 2002. Building on the sympathetic treatment of Jews in Scandinavia during

Figure 62
Maria Frank Abrams at her A Vizualart Galeria opening in Budapest, with *Icy Peaks* (1983), 1994

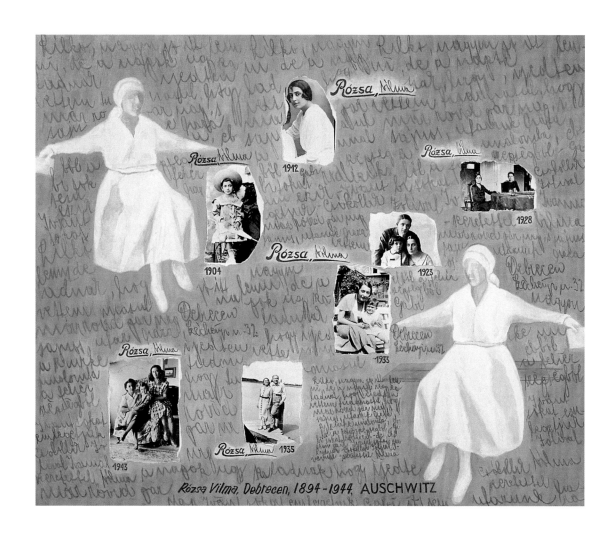

Figure 63
Rózsa Vilma (2001), 2001
Mixed media photo collage
33 x 39 ½

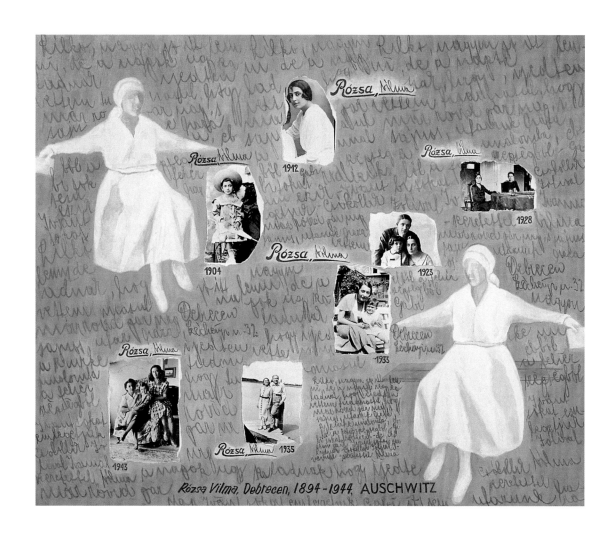

Figure 63
Rózsa Vilma (2001), 2001
Mixed media photo collage
33 x 39 ½

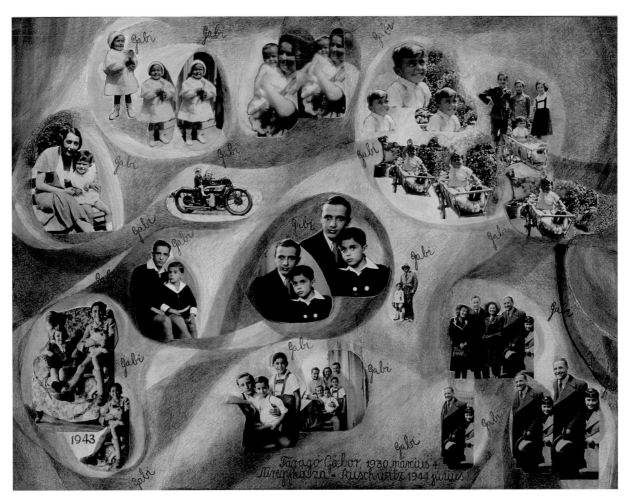

Figure 64
Faragó Gábor, 2002
Mixed media photo collage
29 ½ x 39 ¼

World War II, Forsblad, together with Washington State senator Ken Jacobsen, began an annual event in the form of a dinner commemorating the Swedish diplomat who saved many Jews in Budapest during the war, Raoul Wallenberg (1912–ca. 1947), bringing together Jewish- and Scandinavian-Americans in the Puget Sound area.

Inspired by the opportunity, the seventy-eight-year-old artist created the four Holocaust panels that were the exhibition's centerpiece, *Rózsa Vilma* (2001), *Faragó Gábor*, *Létay Ivan*, and *Faragó György* (all 2002). Initial preparations for these complex photo-collages began during her last visit to Hungary in 1998 when she copied archival photographs of Hungarian soldiers and gendarmes in their uniforms at the Hungarian News Agency Corporation in Budapest. In collaboration with photolab specialist and photographer Dana Drake of Panda Photographic Laboratories in Seattle, fine-textured reproductions were made from archival family photographs chosen by Abrams from hundreds of snap-shots rescued from albums of the 1930s and early 1940s that miraculously survived and were found after the war. The memorial panels treat the lives of four relatives, each with a distinctive composition and set of images. Rephotographed and transferred to acid-free paper and then drawn and painted upon, the original photographs are of a maternal aunt (Vilma Rózsa Faragó, 1894–1944), the aunt's two sons (Gábor, 1930–1944, and György Faragó, 1921–1944 or 1945), and the son of her aunt Lilly Rózsa Létay (1904–1944), (Iván Létay, 1937–1944) although numerous other family members are also featured in the backgrounds. The first three panels commemorate relatives who were murdered in Auschwitz. First, Iván, on July 1, 1944, the day the family arrived from Debrecen, when they were "selected" and separated from Marika Frank soon after descending from the boxcars. (Her mother, Irén, 1891–1944, and father, Ede, 1889–1944, were in the same group led to the showers, but young Marika

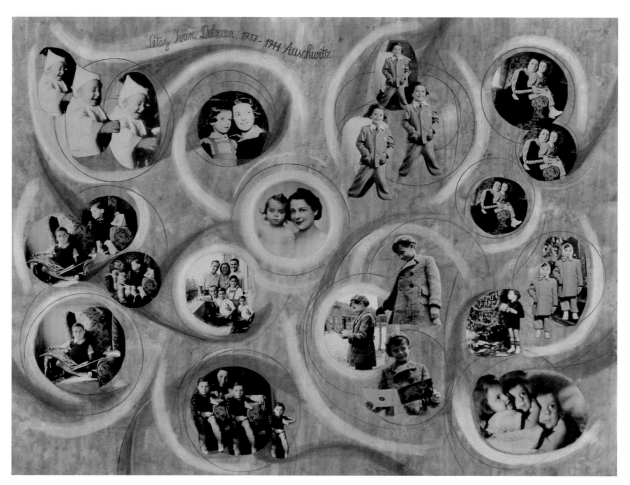

Figure 65
Létay Iván, 2002
Mixed media photo collage
28 ½ x 39 ½

did not learn of their certain fate until several months later.) Then, Vilma Faragó and her son Gábor, in June when their transport arrived from the town of Nyíregyháza. And finally György Faragó, who died in a forced-labor battalion in an unknown location, possibly on the Austrian border.

Averaging three feet square, the panels are filled with souvenir photographs of many of the Frank and Rózsa family members, with pale gray backgrounds; all titles use the Hungarian form of address, with last names first. *Rózsa Vilma* is the plainest and simplest, with two large mirror-images of her aunt seated in a white dress. Seven photographs show her life story from girlhood to early middle age. In the background is a text copied from a postcard, of greetings sent to her sister from a winter vacation only five months before her murder in Auschwitz. The handwriting, a painstakingly exact imitation of the original, is rhythmical (Figure 63). *Faragó Gábor* includes posed family portraits and summer

vacation snapshots of Vilma's ten-year-old son, often held and protected by his older brother (Figure 64). *Létay Iván* portrays an even younger child and emphasizes protective family groupings surrounding the little boy (Figure 65). *Faragó György* is larger, nearly four feet square, with a landscape of farmhouses and buildings, including the family's summer villa in the Carpathian Mountains, in addition to more ominous structures, perhaps alluding to the barracks of the labor service camp where he perished. He is shown in the clothing and yellow armband of the Jewish labor service (Figure 66). The handwriting is copied from postcards he wrote during the second half of 1944, when he was not aware of the fate of his family, to an aunt who lived with her gentile nobleman husband in Budapest. Some excerpts from the postcards are:

The news I get from my parents, alas, is not good. They are to leave Nyíreghiháza on the

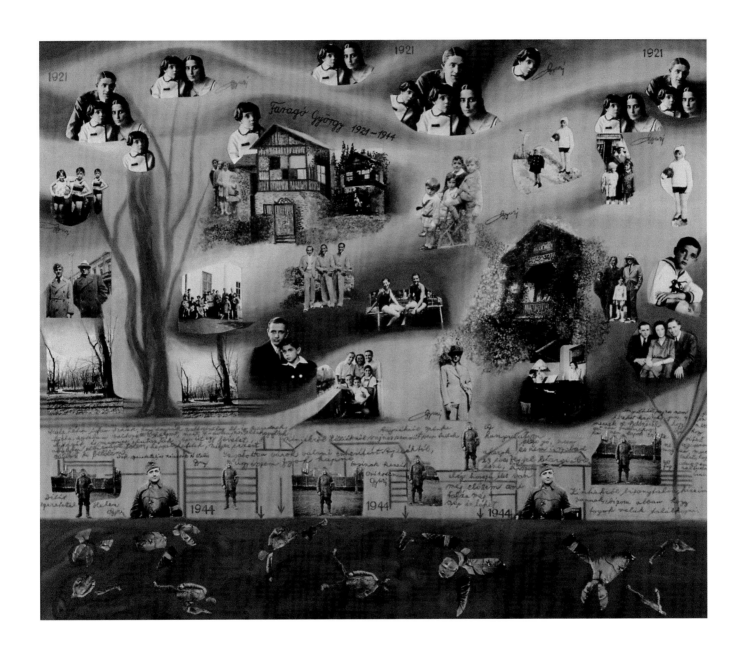

Figure 66
Faragó György, 2002
Mixed media photo collage
28 ½ x 39 ½

fourth of June. Where to—I do not know. Dad writes that I should not worry if I do not receive news from them because it is possible that for a while they won't be able to write.

Last week I wrote you that my own family most likely will stay until the 21st, meanwhile the situation has changed and they left Nyíregyháza for far away. Dad wrote me a letter, he took leave and said "good-bye." I leave it to you to imagine the rush of feeling that enveloped me.

From my parents, from Aunt Irenke's family, Lilly and Iván, alas, I have no news. I know nothing.

I am very anxiously waiting some communications from my parents. I have a strong feeling that I will receive something.

My mood is good enough. It would not be right that at age 23 to abandon myself to despair; after all, a long life is ahead of me which could still be good.

Of those who were sent away, I have uncertain, confusing reports. I have faith that I will see them in the future.

With the completion of the memorial panels, Abrams fulfilled something she felt she had previously failed to do in her art: express her sentiments about remembering and memorializing her family members lost to the Holocaust. Perhaps as a result of the numerous addresses to student groups and the subsequent invitations to speak in public—at the University of Washington, the Frye Art Museum, and for various church and synagogue groups—she may have felt a greater confidence in approaching the painful subject. Indeed, in the Englehart interview, videotaped for the Steven Spielberg–funded *Survivors of the Shoah*, when the artist discusses the same family photographs the camera is stopped more than once due to the speaker being over-

come with tears. Invariably, the viewer of the interview feels the same way.

More clear-eyed in the studio, Abrams built panels that draw meaningful elements together into a perfect composition, a fundamental skill she mastered many years before in Walter F. Isaacs's classes. With a voluminous amount of disparate material to organize, each "storyboard" is a balanced construction that employs a different structural solution. Collectively a distinct phase or body of work separate from all the artist's previous achievements, the panels mark a summation point; the artist poetically composes the photographic images that act as talismanic memory triggers without resorting to explicit imagery of the concentration camps. Here, drawing on the deep appeal of a family scrapbook, Abrams has tamed or omitted the horror behind the family photos, the cruel inevitability of steps that led to the murders of the honorees.

It is also important to note that these panels were undertaken after all the artist's comments about never confronting the experiences in her art and her regrets about this "failure." Given the opportunity by Marianne Forsblad, the museum director, however, Abrams drew upon her considerable powers of imagination to make the selection of images that worked well together in each panel. As such, to the attentive viewer, they bookend her career, harking back to the earliest paintings of chimneys, guard towers, barracks, and the burning forest while creating a vantage point for others—non-family members and non-Holocaust survivors—to vicariously cherish the lost loved ones and marvel at the curving, swirling lines that contain and protectively nestle them. Begun as snapshots of vacations and formal studio portraits taken in Debrecen, such source materials are transformed into moving vignettes that become art of the highest order.

Seen in the light of the memorial panels, a close symbolic reading of the earlier paintings, drawings, and prints now seems more plausible, even if not obvious. Through the vehicles of landscape and modernist abstraction—Abrams's inherited vocabulary of her mid-twentieth-century education—the artist traveled forward in time to the panels. Her literal travels to Israel and Europe—France, Italy, Hungary, and elsewhere, but never

Germany—reconnected her to her earliest years and repaired the break or tear in European culture and civilization to which she had been subjected.

Developing as an artist in the United States, she may now be seen as an exile from European art whose art may indirectly relate to that tradition. At the same time, her intricately balanced interface, both with Tobey's "mystic" art and that of the university moderns like Isaacs, the Pattersons, Brazeau, and Moseley, anchors her within a parallel tradition, the nature-rooted American art of the Pacific Northwest and the American manifestations of modernism. It is this rare blending and fusing of the three traditions that constitutes the strength of her achievement and underscores her contribution to all three cultural strains.

NOTES

[1] Maria Frank Abrams, interview in Sylvia Rothchild, ed., *Voices From the Holocaust*. New York: New American Library, 1981, 321.

[2] Maria Frank Abrams, untitled address, unpublished typescript, 1983.

[3] Theodore Roethke, "The Lost Son," in *Roethke: Collected Poems*. New York: Doubleday, 1966, 58.

[4] György Szegő, "Fénygyógymód—ecsettel, Maria Frank Abrams kiállitása a Vizualart Galériában," *Mult és Jövo* 1992 (4), 124–125.

[5] The other artists were Gizel Berman, Akiva Sagan, and Selma Waldman.

[6] See Stephen Weinstein, *Witness & Legacy: Contemporary Art About the Holocaust*. St. Paul, MN: Minnesota Museum of American Art, 1996.

[7] "Annual Scholars' Conference on the Holocaust and the German Church," held at University of Washington, Seattle, 1996. Abrams's typescript is in her private archival papers.

[8] Janice Englehart. Interview with Maria Frank Abrams, *Survivors of the Shoah: Visual History Foundation*, December 8, 1995. Part I, 1 hr., 40 min.; Part II, 2 hrs., 26 min. Transcribed by Sharon Prosser, 2009, Part II.

PLATES

Plate 1
Untitled Notebook Page, Stuttgart, 1947
Pencil on paper
11 x 8

Plate 2
Three Standing Nudes, 1948
Pencil on paper
24 x 18

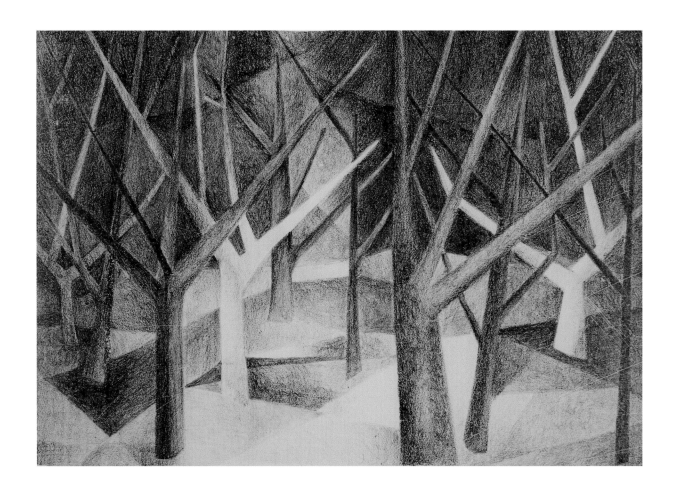

Plate 3
Forest, 1950
Lithograph on paper, edition of 8
9 x 12 ½
Arthur and Alice Siegal Collection

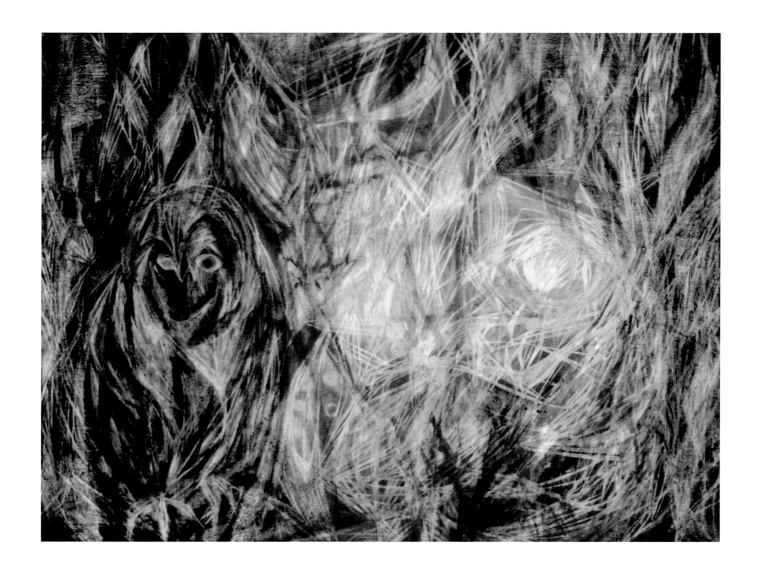

Plate 4
Day and Night, ca. 1954
Oil on board
15 ¾ x 21 ½
Agnes Jacobson Collection, Santa Barbara, California

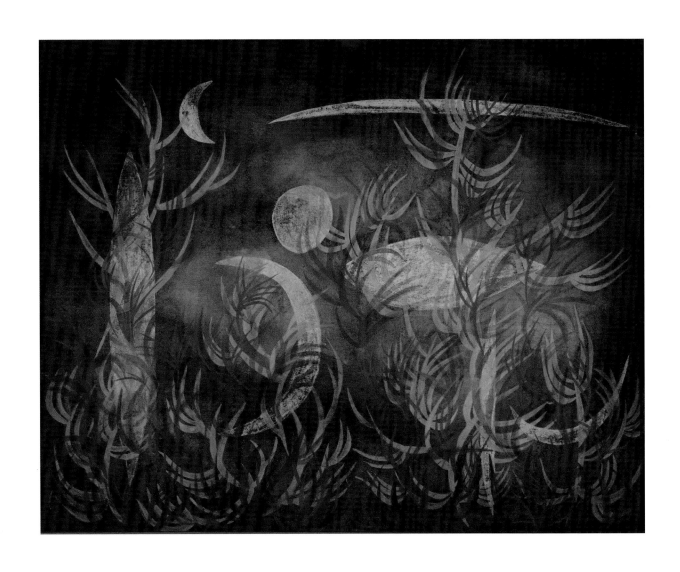

Plate 5
Many Moons, 1957
Casein on paper
11 x 13 ½

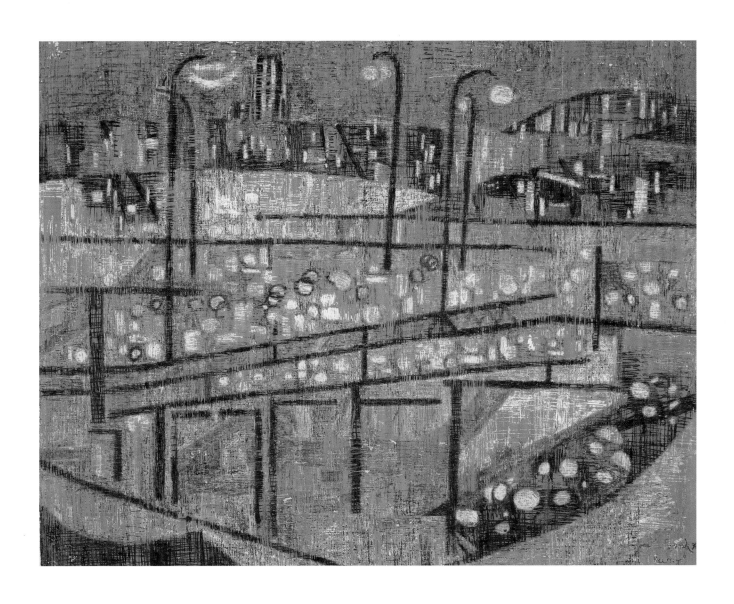

Plate 6
Ramp, 1961
Mixed media and crayon on paper
18 ½ x 23

Plate 7
Design for mosaic panel, 1958
Watercolor and casein on paper
3 ½ x 13 ½
Location unknown

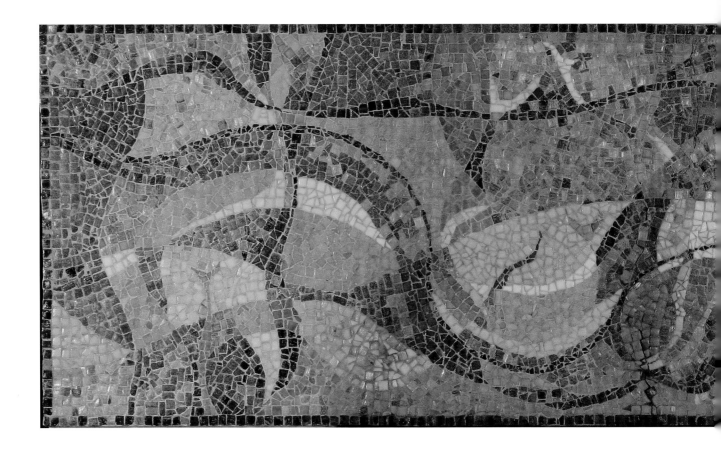

Plate 8
Above: *Be Gentle as the Dove and Wise as the Snake*, 1958
Glass mosaic
36 x 156

Plate 9
Right: Design for mosaic panel, *Be Gentle as the Dove and Wise as the Snake*, 1958
Casein on paper
3 ½ x 13 ½

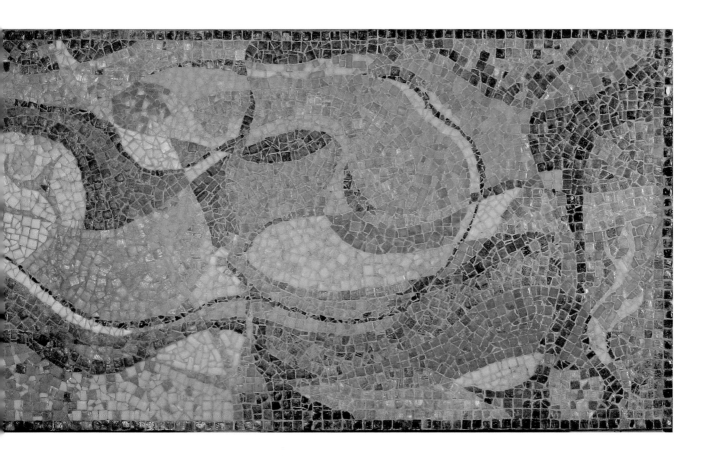

Plate 10
Dawn, 1960
Casein and crayon on board
29 ¼ x 11 ¾
Gift of the artist
Jundt Art Museum, Gonzaga University, Spokane, Washington

Plate 11
Rhythmic Forest, 1969
Ink, pen, and wash on paper
16 ½ x 22 ½
Gift of the artist
Henry Art Gallery, University of Washington 2008.214

Plate 12
Organic, 1959
Watercolor and ink on paper
18 ⅞ x 22 ⅝
Gift of Sidney and Anne Gerber
Seattle Art Museum 65.156

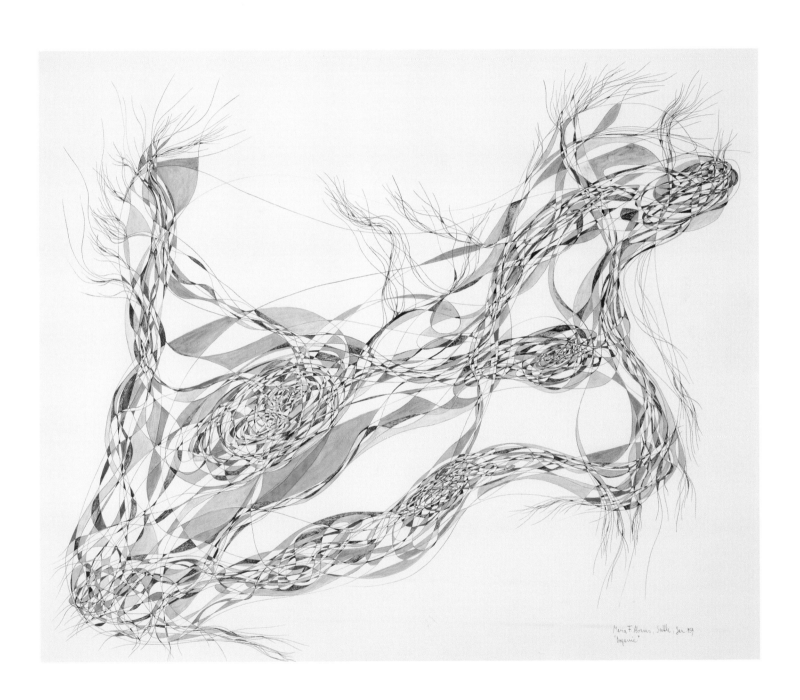

Maria F. Abrams, Seattle, Jan '89
"Ingenue"

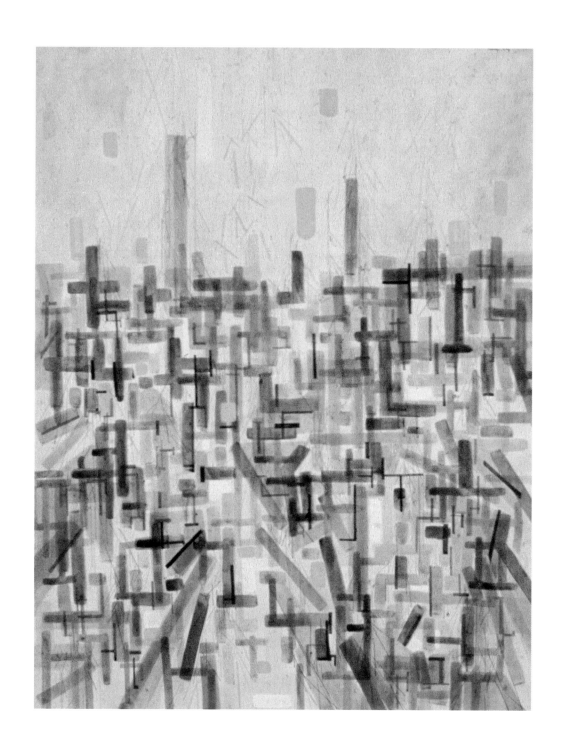

Plate 13
City, 1962
Casein on paper
29 x 20
Courtesy of Gordon Woodside / John Braseth Gallery

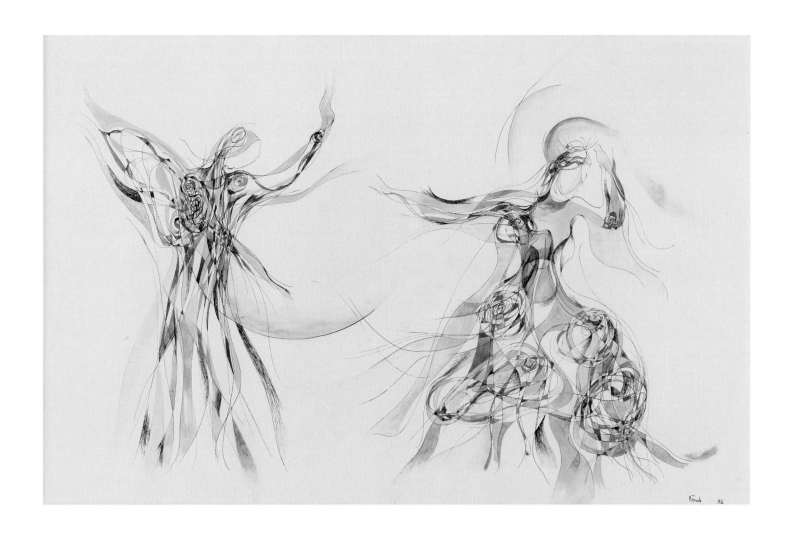

Plate 14
Annunciation, 1966
Ink and watercolor with wash on paper
14 ¾ x 22 ¾
Gift of the artist
Jundt Art Museum, Gonzaga University, Spokane, Washington

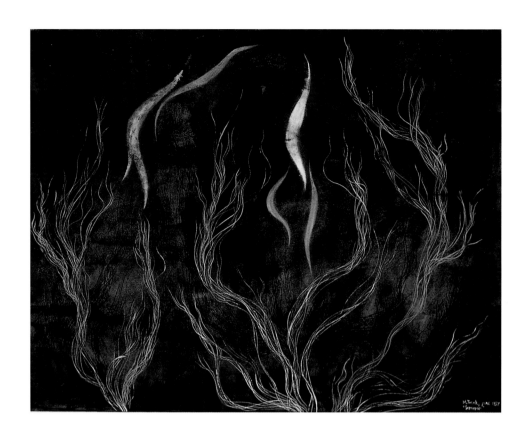

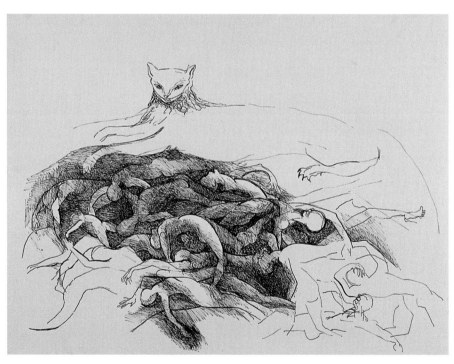

Plate 15
Sorrow, 1957
Casein on paper
9 ¼ x 23 ¾
Location unknown

Plate 16
Keeper of Graves, 1964
Pen and ink on paper
10 ½ x 14 ½

Plate 17
The Parting, 1966
Pen, ink, and wash on paper
16 ½ x 23
Yad Vashem Holocaust Martyrs' and Heroes'
Remembrance Authority,
Jerusalem, Israel

Plate 18
Remembrances, 1966
Casein on paper
28 x 20
Location unknown

Plate 19
Summer Festival, 1968
Casein on paper
dimensions unknown
Estate of Mrs. Sam Heller, Vancouver, BC, Canada

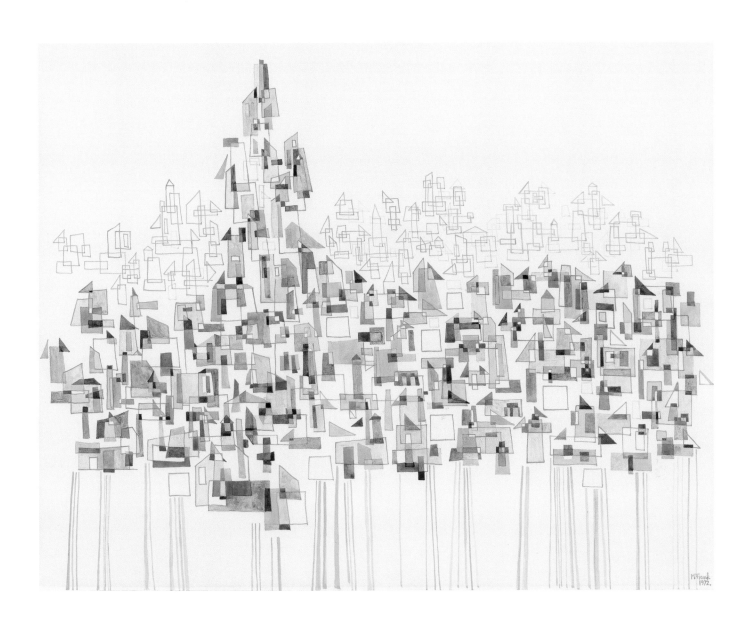

Plate 20
Floating City, 1972
Watercolor and casein on paper
19 ¼ x 24 ¾
Gift of the artist
Jundt Art Museum, Gonzaga University, Spokane, Washington

Plate 21
Untitled, 1977
Pencil on paper
12 x 20
Gift of Mr. and Mrs. Sydney Abrams
Whatcom Museum of History & Art, Bellingham, Washington

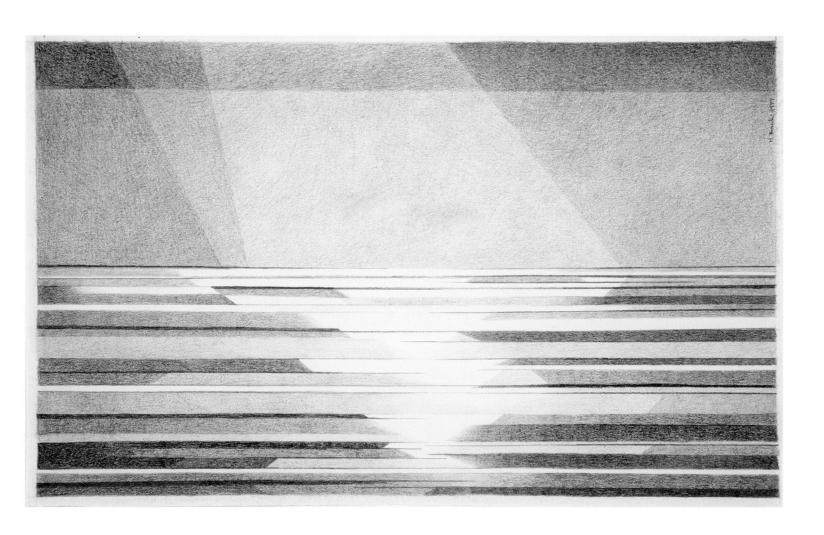

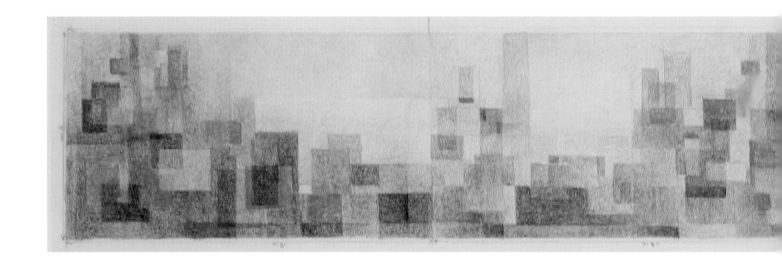

Plate 22
Design for the mural *The Four Seasons*, 1976
Colored pencil on paper
7 ½ x 40 ½

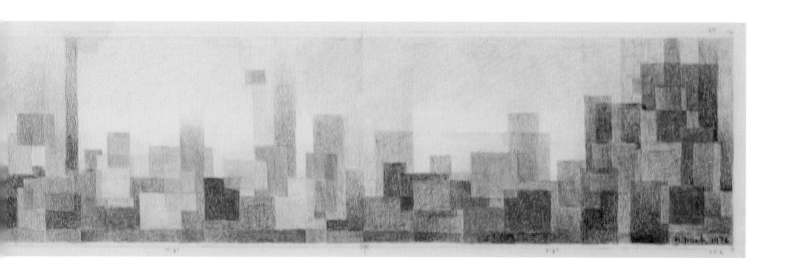

Plate 23
Receding Horizons, 1983
Casein on paper
28 x 21 ½
Courtesy of Gordon Woodside / John Braseth Gallery

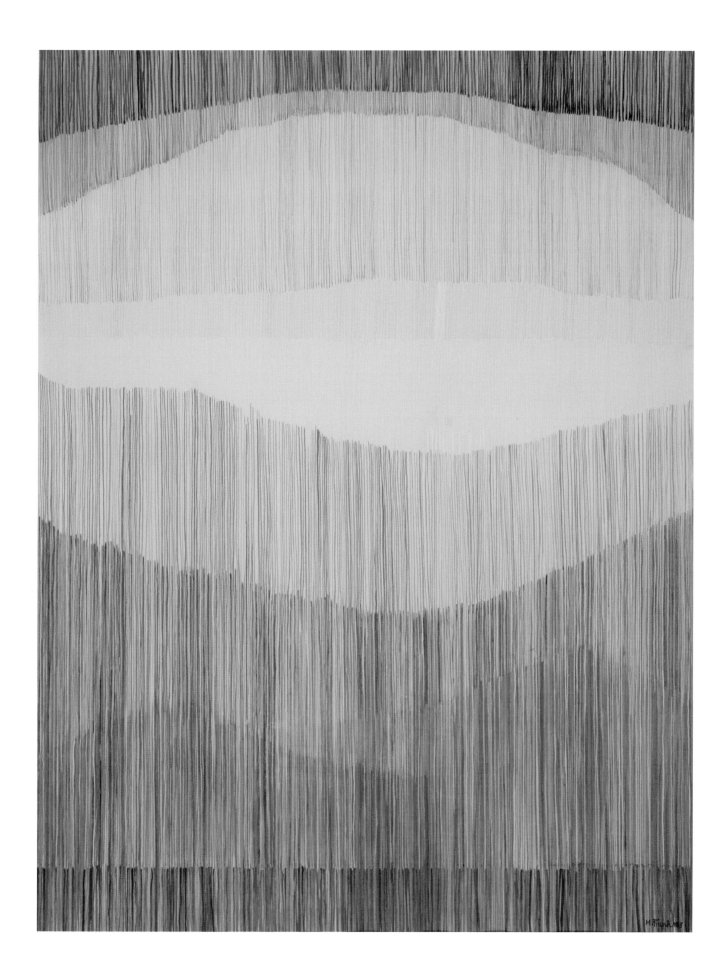

Plate 24
Moon Reflections, 1987
Casein on paper
28 x 32 ½
Gift of the artist
Henry Art Gallery, University of Washington 2008.217

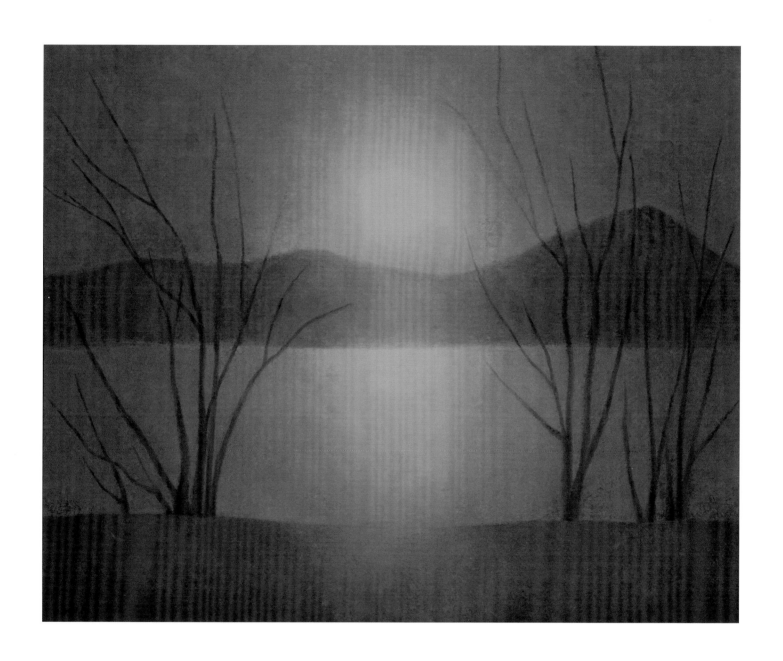

Plate 25
Winter's Moon, 1987
Oil on canvas
44 x 54
Gift of Sydney Abrams and Maria Frank Abrams
Museum of Northwest Art 08.208.49

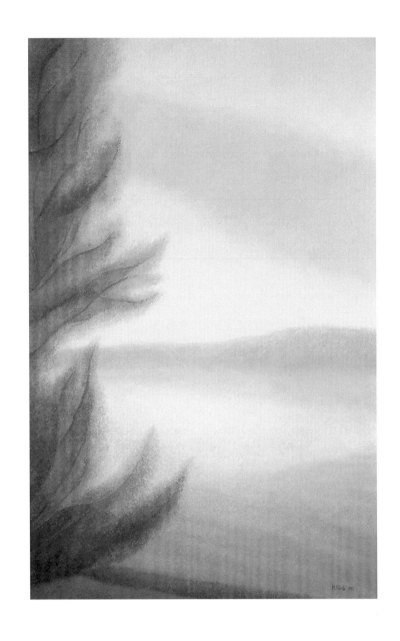

Plate 26
Autumnal Eve, 1985
Oil on canvas
66 ½ x 42 ½
Courtesy of Gordon Woodside / John Braseth Gallery

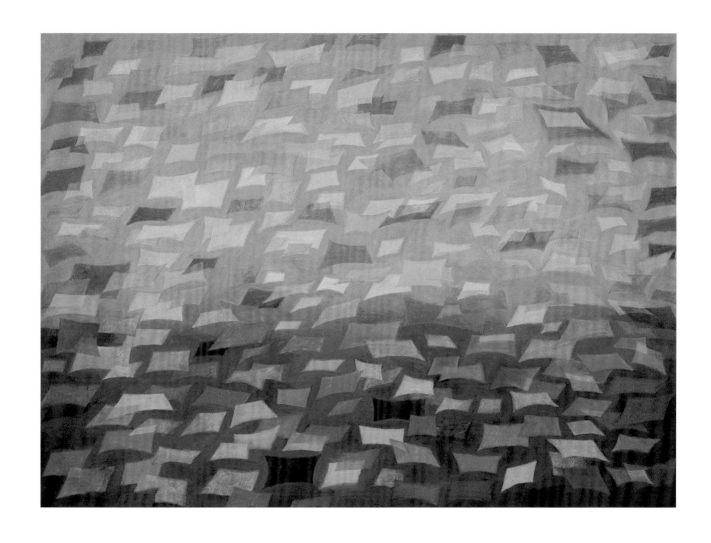

Plate 27
Summer Leaves, 1995
Oil on canvas
38 x 52
Collection of Tom Bailiff, Seattle

Plate 28
Winter Twilight, 1995
Casein on paper
25 ¾ x 30 ½
Dr. Cyrus and Mrs. Grace Rubin Collection, Mercer Island, Washington

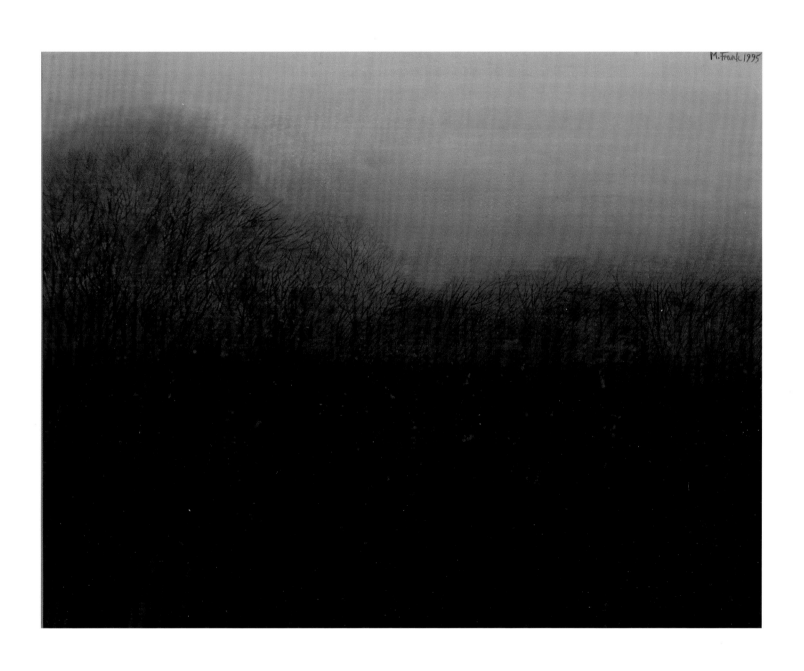

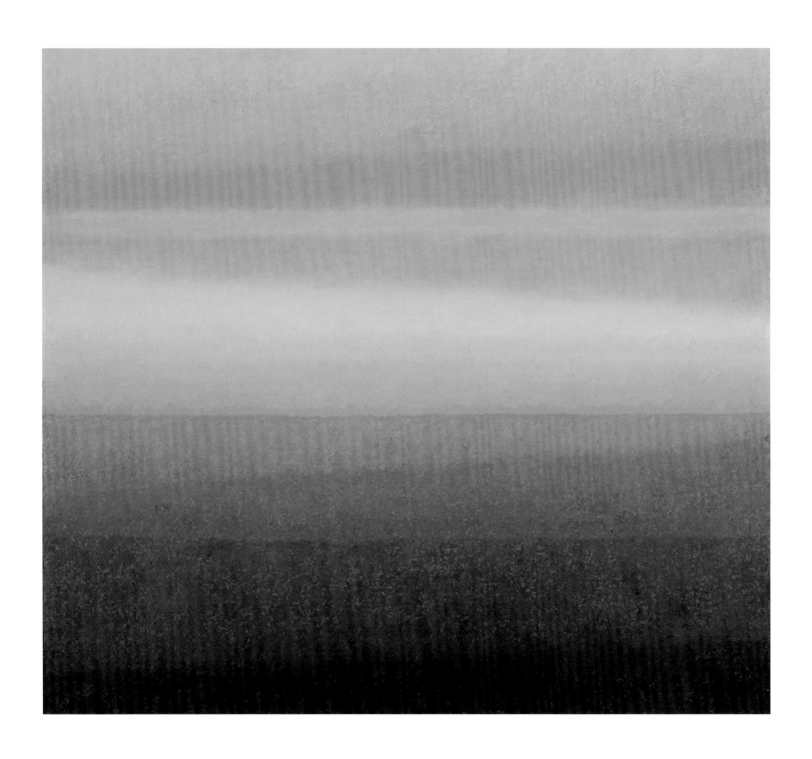

Figure 67
Autumn Sundown, 1978
Oil on canvas
40 x 44
Bailey Nieder collection

MARIA FRANK ABRAMS

BIOGRAPHY

Born Marika Franciska Frank, Debrecen, Hungary, July 21, 1924

Daughter of Ede Frank (1889–1944) and Irén Rózsa (Mrs. Ede Frank) (1891–1944)

Deported to Auschwitz-Birkenau, Poland, June 28, 1944; Bergen-Belsen, Germany, September 1944; satellite camp of Buchenwald at Magdeburg, Germany, December 1944; released, Magdeburg, Germany, April 1945

Worked for the American Jewish Joint Distribution Committee in Linz, Austria, and Stuttgart, Germany, 1946–1947

Arrived in the United States, 1948

Married Sydney A. Abrams (b. 1927), 1948

Naturalized American citizen, 1954

One son, Edward Frank, b. 1952

One grandson, Omri, b. 1986

One granddaughter, Noga Vilma, b. 1991

Resides on Mercer Island, Washington

Represented by Gordon Woodside/John Braseth Gallery, Seattle

EDUCATION

University of Washington, MLS, 1964

Private seminar, Mark Tobey studio, Seattle, 1952

University of Washington, School of Art, 1951, BFA, summa cum laude

Kuenstlerich Wissenschaftlich, Stuttgart, West Germany, June–July 1947

Trade and Commerce High School, Debrecen, Hungary, 1938–42

Gymnasium Dóci Leány (Protestant Girls Middle School and High School), Debrecen, Hungary, 1934–38

Jewish Girls Elementary School, Debrecen, Hungary, 1930–34

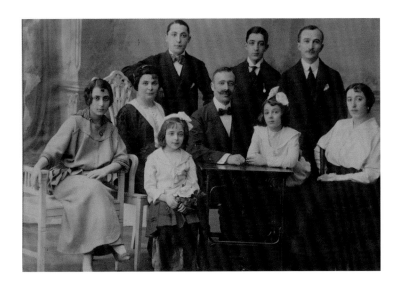

Figure 68
Rózsa family members; back row: Endre Rózsa, Árpad Rózsa, Ede Frank; seated: Vilma Rózsa, Malvin Stern, Katö Rózsa, Lajos Rózsa, Lilly Rózsa, Irén Rozsa, 1913

SOLO EXHIBITIONS

2010
Gordon Woodside / John Braseth Gallery, Seattle

2007
Gordon Woodside / John Braseth Gallery

2003
East Shore Gallery, East Shore Unitarian Church, Bellevue, Washington

2002
Nordic Heritage Museum, Seattle

1996
Fine Arts Gallery, Pacific Lutheran University, Tacoma, Washington
"Maria Frank Abrams Paintings," Art Center Gallery, Seattle Pacific University

1992
A Vizualart Galeria, Budapest, Hungary
Group Health Central Mental Health Facility, Seattle

1991
Janet Huston Gallery, La Conner, Washington

1986
"Paintings by Maria Frank Abrams," Lee Theater and Arts Center, Forest Ridge School, Bellevue, Washington

1985
"Maria Frank Abrams Paintings," Meany Hall Fine Arts Gallery, University of Washington. Erica Williams and Anne Johnson, curators

1980
"Maria Frank Abrams Landscapes," Gallery West, Portland, Oregon

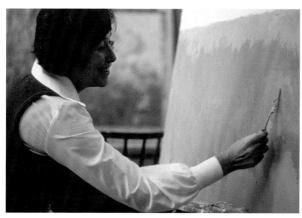
Figure 69
Studio View, Mercer Island, Washington, October, 1978

1979
"Maria Frank Abrams Paintings," Kirsten Gallery, Seattle

1977
Gallery West
University Unitarian Fine Arts Gallery, Seattle
Rentaloft Gallery, Seattle Art Museum Modern Art Pavilion

1976
Moldrem Atelier of Art, Seattle
Kirsten Gallery

1974
Moldrem Atelier of Art

1973
"Maria Frank Abrams Paintings," Gallery West
"Maria Frank Abrams Paintings," East Shore Gallery, East Shore Unitarian Church
Old Jaffa Gallery, Tel Aviv, Israel

1972
University Unitarian Fine Arts Gallery

1971
Gallery West

1970
Gallery West

1967
Canvas Shack, Vancouver, BC, Canada

1966
Seattle Art Museum
Fine Arts Gallery, Pacific Lutheran University
Otto Seligman Gallery, Seattle

1960
Otto Seligman Gallery
University of Puget Sound, Tacoma, Washington

1958
Marylhurst Art Center, Marylhurst, Oregon
Otto Seligman Gallery

1957
Seattle Art Museum
B. K. Alsin, Seattle
Jewish Community Center, Portland, Oregon
Gallery West

1953
Otto Seligman Gallery
Norman Vowles Interiors, Bellevue, Washington

Figure 70
Maria Frank Abrams and Estika Hunnings, at the Canvas Shack, Vancouver, BC, 1967

GROUP EXHIBITIONS

2010
Gordon Woodside / John Braseth Gallery

2009
Museum of Northwest Art, La Conner, Washington

2001
"Maria Frank Abrams / Gizel Berman / Akiva Segan / Selma Waldman," Charles and Emma Frye Art Museum, Seattle; Richard V. West, curator

2000
Lambda Rho Exhibition, West Lake Union Center, Seattle

1999
"What It Meant to Be Modern: Seattle Art at Mid-Century," Henry Art Gallery, University of Washington. Sheryl Conkelton, curator
Lambda Rho Exhibition, West Lake Union Center

1998
"The Work of Maria Frank Abrams, Kayla Kosoglad, Deborah Mersky, and Selma Waldman," Allison / Beeman Fine Arts Services, Seattle

1997
"Northwest Watercolor Society Annual Exhibition," Tolles Gallery, Mercer Island, Washington. Juror: Skip Lawrence

1995
"Showcase '95," Beaverton Arts Commission, Beaverton, Oregon. Juror: Joseph Biel
"Lambda Rho: Art Honorary," Art Center Gallery, Seattle Pacific University

1994
Lambda Rho Exhibition, Art Center Gallery, Seattle Pacific University

1993
Galerie Charlotte Daneel, Amsterdam, Netherlands
"An Exhibition of Northwest Artists," Greystone Homes at Lakemont, Bellevue, Washington. Phillip Levine, curator
"Budapest-Seattle Art Exchange: The Third International Artist-to-Artist Goodwill Exhibition," Seattle Central Community College Art Gallery. Maria Frank Abrams, curator

1992
"Naturalism to Abstraction in Watercolor," North Seattle Community College Gallery, Seattle
"Holland Meets the USA," Galerie Charlotte Daneel, Amsterdam, Netherlands
"Vision 20/20: Seattle and Dutch Artists," Seattle Central Community College Art Gallery
"Fifty-second Annual Exhibition of Northwest Watercolors," Howard / Mandville Gallery, Kirkland, Washington. Juror: Gerald Brommer

1991
"Twenty-fourth Annual Summer Celebration & Arts Festival," Mercer Island Visual Arts League, Island Plaza. Juror: Gervais Reed
"Fiftieth Annual Exhibition of Northwest Watercolors," Stonington Gallery, Seattle. Jury: Charles Svob, Liza von Rosenstiel, Gervais Reed

1990
"Watercolor, Watercolor, Watercolor," Bellevue Art Museum
"Seattle*Barcelona Artists' Exchange," Seattle Central Community College Art Gallery. Fire Cruxent, curator
"International Exchange Exhibition," Taller de Pubilla Cases, Barcelona, Spain. Fire Cruxent, curator
"Twenty-third Annual Summer Arts Festival," Mercer Island Visual Arts League, Island Plaza. Jury: William Hixson, Joyce Moty

1989
"Forty-ninth Annual Exhibition of Northwest Watercolors," Bellevue Art Museum

1988
"The Dybbuk," Judah L. Magnes Museum, Berkeley, California and Jewish Community Gallery, Los Angeles

1987
The Art Complex, Duxbury, Massachusetts

1986
"Blank Wall Solution," The Public Art Space, Seattle

1985
"Forty-third Annual Exhibition of Northwest Watercolors," Bellevue Art Museum. Jury: Karen Guzak, Marshall Johnson, Jacob Lawrence

1983
"Maria Abrams and Dale Donovan," Gallery West, Portland, Oregon
"Art Mercaz: First Annual Showing of Northwest Jewish Artists," American Jewish Committee, Seattle
"Northwest Scenes and Landmarks," Panaca Gallery, Bellevue, Washington. Juror: William Ryan

1980
"Third Annual Northwest Group Show Invitational," Polack Art Gallery, Jewish Community Center, Mercer Island

1979
"Thirty-ninth Annual Exhibition of Northwest Watercolors," Northwest Watercolor Society, Bellevue Art Museum. Jury: Walter Graham, Mary Elise Gray, Louis Kollmeyer
"Jeff Day and Maria Frank Abrams," Kirsten Gallery, Seattle

1977
"Thirty-seventh Annual Exhibition of Northwest Artists," Northwest Watercolor Society, Bellevue Art Museum. Jury: Mervyn Bailey, Ted Rand

1975

Governor's Invitational Exhibition, State Capitol Museum, Olympia, Washington. George Tsutakawa, curator

"Gizel Berman Sculpture and Maria Frank Abrams Paintings," Gallery West, Portland

"Grand Galleria 1975 Competition," Cascade Gallery, Seattle Center. Jury: John Constantine, E. F. Sanguinetti

"Northwest Watercolor Society Thirty-fifth Annual Exhibition," Cascade Gallery, Seattle Center. Jury: Julie MacFarland, Nelson Sandgren, Del Gish

"Maria Frank Abrams / Irwin Caplan / Phillip Levine / Lisel Salzer," Jewish Community Center, Mercer Island

1974

"Sixteenth Annual Puget Sound Area Exhibition," Frye Art Museum, Seattle. Juror: Gunnar Anderson

"Thirty-fourth Annual Exhibition of Northwest Watercolor Society," Cascade Gallery, Seattle Center. Jurors: Maria Frank Abrams, George Hamilton, Irwin Caplan

1973

"Thirty-third Annual Exhibition of Watercolors," Northwest Watercolor Society, Seattle Art Museum Pavilion. Jurors: Bill Colby, Emily Hall Morse, Arne Jensen

1972

"Survivors '72," Henry Art Gallery, University of Washington

"Art 1972," Western Washington Fair, Puyallup. Jury: LaMar Harrington, Anne Gerber, Bill Colby

1971

"Fifty-seventh Annual Exhibition of Northwest Artists," Seattle Art Museum Pavilion. Juror: Gerald Nordland

1970

"Twenty-eighth Annual Exhibition of Northwest Watercolors," Seattle Art Museum Pavilion

1969

"Twenty-ninth Annual Exhibition of Watercolors," Seattle Art Museum Pavilion. Jury: Harry Bonath, Fay Chong, Norman Jacky

1967

"Twenty-seventh Annual Exhibition of Northwest Watercolors," Seattle Art Museum. Jury: Irwin Caplan, Fred Griffin, Gus Swanberg, Lyle Silver

"Summer Salon," Henry Art Gallery, University of Washington. Spencer Moseley, curator

Pomeroy Galleries, San Francisco

"Washington State Chapter of Artists Equity Association Member Exhibition," State Capitol Museum, Olympia,. and National Art Gallery, Bon Marché, Seattle

Canvas Shack, Vancouver, BC, Canada

1966

Governor's Invitational Exhibition, State Capitol Museum; toured to Municipal Art Museum, Kobe, Japan, as "Thirty-five Seattle Artists: An Exchange Exhibition Between the Sister Cities of Seattle and Kobe." Richard E. Fuller, curator

"Artists of the Seligman Gallery," Museum of Art, University of Oregon, Eugene

"Maria Frank Abrams / Rand Robin," Francine Seders Gallery, Seattle

"Paintings and Crafts by Mercer Island Artists," Island Plaza, Mercer Island. Jury: Irwin Caplan, Phillip Levine

"Twenty-sixth Annual Exhibition of Northwest Watercolors," Seattle Art Museum Pavilion. Jury: George Laisner, Michael Dailey, James Peck, Lyle Silver, Edward Thomas

1965

"Twenty-fifth Annual Exhibition of Northwest Watercolors," Seattle Art Museum Pavilion. Jury: Jess Cauthorn, Neil Meitzler, George Tsutakawa, John Ringen

"Eleventh Annual West Coast Oil Paintings Exhibition," Frye Art Museum. Jurors: Leon Applebaum, Leon Derbyshire, Ebba Rapp

1964

"Fay Chong / Maria Frank Abrams / Keith Imus," Otto Seligman Gallery, Seattle

"Pacific Northwest Arts & Crafts Fair," Bellevue, Washington. Juror: George Culler

"Twenty-fourth Annual Exhibition of Northwest Watercolors," Seattle Art Museum Pavilion

"First Invitational Exhibit of Works of Art by Mercer Island Artists," Emmanuel Episcopal Church Guild Hall, Mercer Island

1963

"Ninth Annual West Coast Oil Paintings Exhibition," Frye Art Museum. Juror: Ebba Rapp

1962

"Northwest Artists of the Seligman Gallery," Otto Seligman Gallery

"Washington Artists 1962," Western Washington Fair. Juror: Nathan Oliveira

"Forty-eighth Annual Exhibition of Northwest Artists," Seattle Art Museum. Jury: Sam Black, Ray Jensen, Wirth McCoy, Gordon Woodside

"Twenty-second Annual Exhibition of Northwest Watercolors," Seattle Art Museum

"Puget Sound Exhibition," Frye Art Museum

"Elisabeth Blaine / Barbara Brotman / Maria Frank Abrams," University Unitarian Church, Seattle

"Eighth Annual West Coast Paintings Exhibition," Frye Art Museum. Jury: Arne Jensen, Ernest Norling

"Fifth Annual Painting Exhibition: Lambda Rho Alumnae," University of Washington Student Union Building. Jury: Anne Gerber, Mercedes Hensley, Eugene Pizzuto

"Ninth Annual Oil Exhibition," Woessner Gallery, Seattle. Jury: William Hixson, Nikolas Damascus, Sydney Eaton

1961

"Maria Frank Abrams and June Nye," Otto Seligman Gallery

"Forty-seventh Annual Exhibition of Northwest Artists," Seattle Art Museum. Jury: Walter Hook, Tom Hardy, Thelma Lehmann, Gervais Reed

"Forty-seventh Annual Exhibition of Northwest Artists," Seattle Art Museum

"Twenty-first Annual Exhibition of Northwest Watercolors," Seattle Art Museum

"Artists of Puget Sound: An Invitational," Henry Gallery, University of Washington

"The Spring Art Show," University Unitarian Church

"Tenth Annual Pine Street Show," I. Magnin, Seattle. Jury: Boyer Gonzales, Alden Mason, Norman Warsinske

"Sixth Annual Drawing Exhibition," Woessner Gallery. Jury: Wendell Brazeau, Irwin Caplan, William Cumming

"Fourth Annual Painting Exhibition Lambda Rho Alumnae," University of Washington Student Union Building. Jury: Ruth Penington, Grace Henning, Steven Fuller

"Eighth Annual Oil Exhibition," Woessner Gallery. Jury: Kenneth Callahan, John Erickson, Thelma Burke

1960

"Maria Frank Abrams / Kathleen Gemberling / William Mair," Jones Hall Galleries, University of Puget Sound, Tacoma, Washington

"Artists of Puget Sound: An Invitational Exhibition," Henry Gallery, University of Washington. Jury: Virginia Banks, Wendell Brazeau, Fay Chong, Barbara James, Norman Warsinske

"Forty-sixth Annual Exhibition of Northwest Artists," Seattle Art Museum

"Twentieth Annual Exhibition of Northwest Watercolors," Seattle Art Museum

"Ninth Annual Art on Pine Street Exhibition," Bon Marché, Seattle. Jury: William Hixson, Thelma Burke, Al Everett

"Third Annual Painting Exhibition Lambda Rho Alumnae," University of Washington Student Union Building. Jury: Boyer Gonzales, Hazel Koenig, Valentine Welman

1959

"Nineteenth Annual Exhibition of Northwest Watercolors," Seattle Art Museum. Jury: Gaylen Hansen, Harold Wohl, Vera Erickson, Richard Prasch

"Maria Frank Abrams and Fay Chong," Otto Seligman Gallery

"Maria Frank Abrams and Millard Petersky," Cellar Gallery, Kirkland

"Artists of Puget Sound: An Invitational Exhibition," Henry Gallery, University of Washington

"78th Annual Painting and Sculpture Exhibition," San Francisco Art Association

"Puget Sound Exhibition," Frye Art Museum

"Fourth Annual Drawing Exhibition," Woessner Gallery

"Sixteen Watercolor Painters," Woessner Gallery

"Northwest Artists," Larson Gallery, Yakima, Washington

"Puget Sound Area Exhibition," Frye Art Museum. Jury: Percy Manser, Ebba Rapp, Roy Terry

"Sixth Annual Oil Show," Woessner Gallery. Jury: Kenneth Callahan, Gervais Reed, Valentine Welman

"Fourth Annual Drawing Exhibition," Woessner Gallery. Jury: Wendell Brazeau, William Hixson, Irwin Caplan

"Fifth Annual West Coast Oil Painting Exhibition," Frye Art Museum. Juror: Adolf Dehn

"Eighth Annual Art Collectors' Tea," Chi Omega House, Seattle. Jury: Neil Meitzler, Boyer Gonzales, Harry Bonath, Ray Jensen, May Marshall

"Second Annual Painting Exhibition Lambda Rho Alumnae," University of Washington Student Union Building. Jury: Viola Patterson, Ambrose Patterson, Walter F. Isaacs

Figure 71
Spring Is Here, 1975
Colored pencil on paper
11 x 12 ½
Joseph E. and Ofelia Gallo collection, Modesto, California

1958

"Pacific Northwest Art Exhibition," Spokane Art Board, Spokane Coliseum, Spokane, Washington. Jury: Glen Alps, Robert Sterling, Paul Gunn, W. W. DeNeff

"Eighteenth Annual Exhibition: Northwest Watercolors," Seattle Art Museum

"Washington Artists 1958," Western Washington Fair

"Eighteenth Annual Washington Artists' Exhibition," Tacoma Art League, Tacoma. Jury: Guy Irving Anderson, Thelma Lehmann, Andrew Vincent

"Twelfth Annual Pacific Northwest Art Exhibition," Spokane Coliseum. Jury: Glen Alps, Robert Sterling, Paul Gunn

1957

"Abrams / Brazeau / Hovde / Wahl," Seattle Art Museum

"Seventeenth Annual Exhibition of Northwest Watercolors," Seattle Art Museum. Jury: John Constantine, Alden Mason, Ted Rand, Gervais Reed

"Washington Artists," Western Washington Fair. Juror: Fred Bartlett

"Pacific Northwest Arts & Crafts Fair," Bellevue

"Sixth Annual Art Collectors' Tea," Chi Omega House. Jury: Boyer Gonzales, Jean Beall, Irwin Caplan, Paul Horiuchi, Allen Wilcox

1956

"Maria Frank Abrams and Russell C. Todd," Otto Seligman Gallery

"Artists of the Seattle Region: An Invitational Exhibition." Henry Gallery, University of Washington. Jury: James FitzGerald, Viola Patterson and Mark Tobey

"Forty-second Annual Exhibition of Northwest Artists," Seattle Art Museum. Jury: Arthur Miller, Glen Alps, Gaylen Hansen, Ted Rand

"Washington Artists 1956," Western Washington Fair. Juror: Mel Kohler

"Fifth Annual Invitational of Fine Art," Frederick & Nelson, Seattle. Jury: Walter F. Isaacs, Gaylen Hansen, Keith Monaghan

"Fifth Annual Collectors' Tea," Chi Omega House. Jury: Guy Irving Anderson, Boyer Gonzales, Gerald Grace, Ebba Rapp, Windsor Utley

"First Annual Drawing Exhibition," Woessner Gallery. Jury: Ambrose Patterson, Nikolas Damascus, Windsor Utley

1955

"Forty-first Annual Exhibition of Northwest Artists," Seattle Art Museum. Jury: Wallace Baldinger, William Hixson, Richard Prasch, Mrs. Daniel Schneider

"Eight Prominent Seattle Women Painters," Otto Seligman Gallery

"Artists of the Seattle Region: An Invitational Exhibition," Henry Gallery, University of Washington. Committee of Invitation: Robert Colescott, Richard Kirsten, Viola Patterson, James Peck, Allen Wilcox

"Fifteenth Annual Exhibition of Northwest Watercolors," Seattle Art Museum. Jury: Harold Wahl, Danny Pierce, Kenn E. Johnson, Donald Peel, Millard Rogers

"Washington Artists 1955," Western Washington Fair

"Pacific Northwest Arts & Crafts Fair"

"Fourth Annual Invitational Exhibition of Fine Art," Frederick & Nelson, Seattle. Jury: Jacob Elshin, James FitzGerald, Norman Davis

"Fourth Annual Art Collectors' Tea," Chi Omega House. Jury: P. K. Nicholson, Danny Pierce, Ed Thomas, George Tsutakawa

1954

"Sixtieth Annual Exhibition of Western Art," Denver Art Museum. Juror: Daniel Defenbacher

"Fortieth Annual Exhibition of Northwest Artists," Seattle Art Museum. Jury: Boyer Gonzales, Guy Anderson, C. D. Graham, Tom Hardy

"Fourteenth Annual Exhibit of Watercolors," Seattle Art Museum

"Western Painters: Annual Exhibition," Oakland Art Museum, Oakland, California. Jury: Daniel Defenbacher, Alexander Fried, Thomas Carr Crowe, Jr., Hazel Salmi, Glen Wessels

"Artists of Washington: An Invitational Exhibition," Henry Gallery, University of Washington. Jury: B. L. Hyde, Walter F. Isaacs, Wirth McCoy, James Peck, Millard Rogers

"Washington Artists 1954," Western Washington Fair. Juror: Daniel Defenbacher

"Pacific Northwest Arts & Crafts Fair"

"Third Annual Invitational Exhibition of Fine Art," Frederick & Nelson. Jury: Nikolas Damascus, Boyer Gonzales, Gervais Reed

"Art Today," Pacific Lutheran College, Parkland, Washington

"Third Annual Art Collectors' Tea," Chi Omega House. Jury: Kenneth Callahan, Louise Gilbert, Richard Kirsten

1953

"Thirty-ninth Annual Exhibition of Northwest Artists," Seattle Art Museum. Jury: Jack Shadbolt, Everett DuPen, Carl Hall, May Marshall

"Twenty-first Fall Annual," Oakland Art Museum. Jury: René Weaver, Maurice Logan, Erle Loran, Paul Mills

"Annual Invitational Exhibition for Washington Artists," Henry Gallery, University of Washington. Gervais Reed, curator

"Thirteenth Annual Exhibition: Northwest Watercolors," Seattle Art Museum. Jury: Paul Mills, Viola Patterson, Richard Prasch, George Tsutakawa

"Washington Artists 1952," Western Washington Fair

"Pacific Northwest Arts & Crafts Fair"

"Invitational Exhibition of Fine Art," Frederick & Nelson. Juror: A. J. Morris

"First Annual Exhibition Washington Artists," Woessner Gallery. Jury: Gerald Grace, Walter Frolich, Henriette Woessner

"Second Annual Art Collectors' Tea," Chi Omega House. Jury: Jacob Elshin, Zoe Dusanne, Gervais Reed

1952

"Thirty-eighth Annual Exhibition of Northwest Artists," Seattle Art Museum. Jury: Mark Tobey, Wendell Brazeau, William Givler, James Peck

"Northwest Watercolor Society," Seattle Art Museum. Jury: Pauline Johnson, Harry Bonath, Rudolph Zallinger, John Manchester

"Washington Artists 1952," Western Washington Fair. Juror: Thomas Carr Crowe, Jr.

"Pacific Northwest Arts & Crafts Fair"

"Art Week on Pine Street Invitational Exhibition," Frederick & Nelson. Juror: Thomas C. Colt, Jr.

1951

"Washington Artists 1951," Western Washington Fair. Juror: Alfred Frankenstein

"Pacific Northwest Arts & Crafts Fair"

SCENIC DESIGN

1981

The World of Sholom Aleichem. Jewish Theatre Company, Jewish Community Center and Temple De Hirsch, Seattle. Story by Arnold Perl; music by John Lester; costume design by Maria Frank Abrams

1963

La Traviata: An Opera in Three Acts. Seattle Opera. Music by Giuseppe Verdi; libretto by Francesco Maria Piave; sets by Maria Frank Abrams

The Dybbuk: An Opera in Three Acts. Seattle Center Playhouse. Music by Michael White; libretto by George Bluestone; sets and costumes by Maria Frank Abrams

SELECTED PUBLIC COLLECTIONS

The Art Complex, Duxbury, Massachusetts

Caroline Kline Galland Home, Seattle

Continental Bank, Portland, Oregon

Far West Savings Bank, Portland, Oregon

First Federal Savings Bank, Portland, Oregon

Great Western National Bank, Portland, Oregon

Henry Art Gallery, University of Washington, Seattle

Jundt Art Museum, Gonzaga University, Spokane,
 Washington

King County 4Culture Art Collection

Mercer Island Public Library, Mercer Island,
 Washington

King County Courthouse, Seattle

Harborview Medical Center, Seattle

Louisiana-Pacific, Portland, Oregon

McNay Art Museum, San Antonio, Texas

Mountain Park Racquet Club, Portland, Oregon

Museum of History and Industry, Seattle

Museum of Northwest Art, La Conner, Washington

Office of Arts and Cultural Affairs, City of Seattle,
 City Light Collection

Planned Parenthood of the Great Northwest, Seattle

Providence Hospital, Portland, Oregon

Qwest, Seattle and Portland

St. Charles Hospital, Portland, Oregon

Seattle Art Museum

US Bank

University of Washington Libraries, Special
 Collections

Wadsworth Atheneum, Hartford, Connecticut

Whatcom Museum of History & Art, Bellingham,
 Washington

Yad Vashem Holocaust Martyrs' and Heroes'
 Remembrance Authority, Jerusalem, Israel

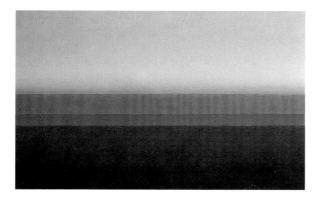

Figure 72
Divided Sky, 1975
Oil on canvas
30 x 48
King County 4Culture Art Collection, Harborview Medical
Center 1977.000P

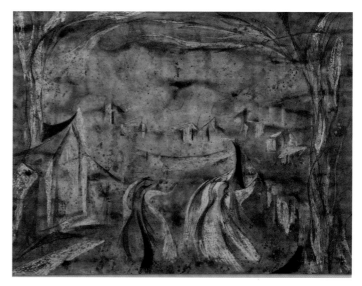

Figure 73
The Dybbuk Will Come, 1963
Ink and watercolor on paper
36 x 42
Seattle Office of Arts & Cultural Affairs, gift of the Seattle Opera
Committee and the Seattle Jewish Community Center to the
City of Seattle GCK74.053

SELECTED AWARDS AND HONORS

1997
Award, "Waterworks '97," Bellevue Art Museum

1990
Designated Signature Member, Northwest Watercolor
 Society

1979
Purchase Award, "39th Annual Northwest Watercolor
 Exhibition," Seattle Art Museum

1976
King County Arts Commission Honors Award

1970
Purchase Award, "Twenty-eighth Annual Exhibition of
 Northwest Watercolors"

1967
First Prize, Mercer Island Arts and Crafts Fair
Award, Henry Art Gallery Invitational Exhibition

1966
Award, Mercer Island Arts and Crafts Fair

1964
First Prize, stained-glass window design, Abbey View
 Memorial Park, Kenmore, Washington
Honorable Mention, Pacific Northwest Arts & Crafts
 Fair

1962
Seattle Playhouse commission, Seattle World's Fair

1961
First Prize, Cellar Gallery, Kirkland, Washington

Second Prize, drawing, Cellar Gallery
Second Prize, drawing, Woessner Gallery, Seattle
Second Prize, "Northwest Watercolor Exhibition,"
 Seattle Art Museum

1959
Award, Woessner Gallery

1957
First Prize, Oil, Pacific Northwest Arts and Crafts
 Fair, Bellevue, Washington

1956
Award, painting, Woessner Gallery

1955
Woessner Gallery Award, Seattle
Award, "15th Annual Northwest Watercolor
 Exhibition," Seattle Art Museum
First Prize, oil, Pacific Northwest Arts and Crafts Fair
Award, "Forty-first Annual Exhibition of Northwest
 Artists," Seattle Art Museum

1954
Award, Pacific Northwest Arts and Crafts Fair
Second Prize, "14th Annual Northwest Watercolor
 Exhibition"
Award, Pacific Northwest Arts and Crafts Fair
Award, "Fortieth Annual Exhibition of Northwest
 Artists," Seattle Art Museum

1953
Award, Woessner Gallery

1952
First Prize, watercolor, Pacific Northwest Arts and
 Crafts Fair
Award, Western Washington Fair

1951
President, Lambda Rho Art Honorary, University of
 Washington
Helen Nettleton Award, University of Washington

1949
Outstanding Woman Student, University of Washing-
 ton School of Art

1948
B'nai Brith Hillel Foundation Scholarship, University
 of Washington

Figure 74
Maria Frank Abrams with *Blue Night*, 1961
Photo courtesy Abrams archive

SELECTED BIBLIOGRAPHY

Albi, G. G. and Gloria B. Peck, eds. *The Artists of Puget Sound*. Seattle: Metropolitan Press, 1962.

"An Exhibition of Paintings . . ." *Oregon Journal* (Portland, OR), November 10, 1957.

Anderson, C. L. "What Seattle Likes in Art." *Seattle Times*, June 14, 1953, 7.

"Abrams' Art in Seattle Gallery." *Mercer Island Reporter*, February 28, 2007, B2.

"Abrams' Paintings in Bellevue Show." *Seattle Post-Intelligencer*, December 13, 1953.

"Abrams Show." *Seattle Times*, January 30, 1972.

"Abrams' Work in Calendar." *Mercer Island Reporter*, August 12, 1992, C4.

"Around the Island: On Exhibit." *Mercer Island Reporter*, June 5, 2002, C1.

"Art Notes." *Seattle Times*, November 11, 1972.

"Art Wins: Chi Omega Collectors Tea." *Seattle Post-Intelligencer*, March 24, 1961, 9.

Basa, Lynn. "Painter Has the Soul of a True Artist," *Journal-American* (Bellevue, WA), February 17, 1986.

Batie, Jean. "Show of Watercolors Has Split Personality." *Seattle Times*, April 23, 1969, 30.

———. "It's Festival Time on Mercer Island." *Seattle Times*, July 2, 1967, 39.

Berman, Gizel. *My Three Lives: A Story of Love, War, and Survival*. Seattle: Innovative Publications, 2000.

Callahan, Kenneth. "University of Arkansas . . ." *Seattle Times*, November 4, 1956.

Campbell, R. M. "An Eclectic Survey of American Photography." *Seattle Post-Intelligencer*, March 28, 1976, G7.

Cassidy, Laura [Learmonth]. "Lightness and Being: A Painter Finds Solace in Memory and Seattle's Oceanic Gray." *Seattle Weekly*, June 12, 2002.

"Cellar Gallery to Open Show." *Seattle Times*, November 11, 1959, 13.

"Church to Show Art by Abrams." *Seattle Times*, May 14, 1977.

Cone, Molly, et al., eds. *Family of Strangers: Building a Jewish Community in Washington State*. Seattle: Washington State Jewish Historical Society and University of Washington Press, 2003.

Conkelton, Sheryl. *What It Meant to Be Modern: Seattle Art at Mid-Century*. Seattle: Henry Art Gallery, University of Washington, 1999, 48.

Crane, Alison. "Maria Frank Abrams, 'A Drive to Paint.' " *Mercer Island Reporter*, September 8, 1966, 1.

Crowe, Thomas Carr, Jr. *Washington Artists 1952*. Puyallup, WA: Western Washington Fair, 1952.

Davis, Jessica. " 'Witness & Legacy' Spotlights Four Local Artists at Frye Museum." *Jewish Transcript* (Seattle), November 24, 2001.

"Editorial: What's This Teenage Desperation All About?" *The Province* (Vancouver, BC), February 21, 1967.

Eskridge, Lee, and Robert Lee. "Art Honorary Alumnae Display Paintings Here." *The Sunday Olympian*, February 3, 1963, 19.

"Exhibit Shows Changing Style." *Seattle Post-Intelligencer*, July 30, 1957.

Faber, Ann. "Boycott Artists Invited." *Seattle Post-Intelligencer*, May 2, 1961, 21.

———. "Printmakers' Show Long on Technique." *Seattle Post-Intelligencer*, December 9, 1966, 36.

Farr, Sheila. "Images of the Holocaust Struggle to Conceive of the Inconceivable." *Seattle Times Ticket*, October 12, 2001, 19.

———. "The Paintings Are Only Part of the Show." *Seattle Times Ticket*, February 16, 2007, 48.

Farrell, Barry. "For Criticism of Professors: Artists Boycott Sorority Exhibit at U. of Wash." *Seattle Post-Intelligencer*, March 21, 1961, 1.

Fortieth Annual Exhibition of Northwest Artists. Seattle: Seattle Art Museum, 1954.

Forty-first Annual Exhibition of Northwest Artists. Seattle: Seattle Art Museum, 1955.

Forty-second Annual Exhibition of Northwest Artists. Seattle: Seattle Art Museum, 1956.

Forty-sixth Annual Exhibition of Northwest Artists. Seattle: Seattle Art Museum.

Forty-seventh Annual Exhibition of Northwest Artists. Seattle: Seattle Art Museum, 1961.

Forty-eighth Annual Exhibition of Northwest Artists. Seattle: Seattle Art Museum, 1962.

"Four KCAC Artists Given Direct Grants." *The Arts—Newsletter of the King County Arts Commission*, September 1976.

Fuller, Richard E. *Thirty-five Seattle Artists: An Exchange Exhibition Between the Sister Cities of Seattle and Kobe*. Kobe, Japan: Municipal Art Gallery, 1966.

"Gallery to Show Works by Maria Frank Abrams." *Portland Jewish Review*, December 1970, 5.

"Gallery West Exhibit Features Northwest Artists." *Valley Times* (Beaverton, OR), January 7, 1971, 12.

Gray, Maxine Cushing. "Opera Future Bright Here." *Argus*, June 7, 1963.

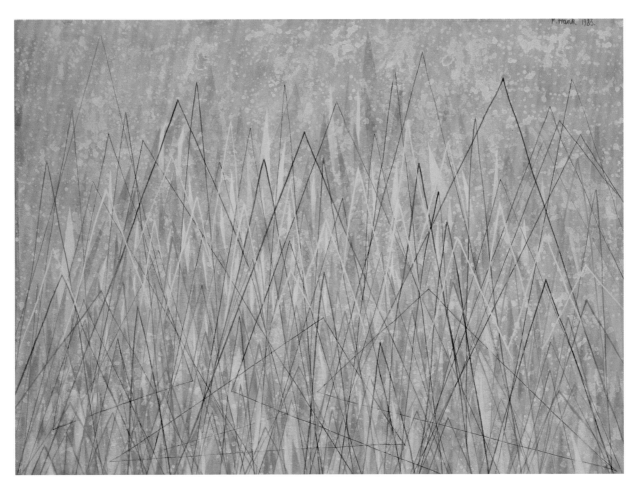

Figure 75
Icy Peaks, 1983
Casein on paper
18 x 24 ½

"Green and Blue." *Seattle Times*, February 25, 2007.

Guzzo, Louis R. " 'Dybbuk' Has Dramatic Power, Brilliant Score." *Seattle Times*, January 7, 1963, 10.

————. "Mary Costa's Violetta Gives 'Traviata' Radiance." *Seattle Times*, May 30, 1963, 30.

Hackett, Regina. "Art: Maria Frank Abrams at Woodside / Braseth Gallery." *Seattle Post-Intelligencer*, March 9, 2007, D8.

Henning, Alice. "Abrams, Petersky Art Show Will Be Featured at Kirkland Cellar Gallery." *The Eastsider*, November 9, 1959.

Holt, Gordy. "Gizel Berman, Artist, Dies at 82: She Was a Survivor of Nazi Death Camps." *Seattle Post-Intelligencer*, February 28, 2002.

"In Solo Show . . . " *Seattle Times*, June 6, 1977.

"In the Art World . . . " *Seattle Post-Intelligencer*, January 28, 1972.

Isaacs, Walter F. *Eight Prominent Seattle Women Painters*. Seattle: Otto Seligman Gallery, 1955.

"Island Artist Featured." *Mercer Island Reporter*, August 29, 1990.

Jones, Catherine. "Candlelight Christmas Tea Scheduled for Tuesday at Portland Art Museum." (Portland) *Oregonian*, December 12, 1954, 12.

Kangas, Matthew. "The University Moderns: How the UW Art Teachers Brought Modern Art to Seattle." *Art-Guide Northwest*, April-October 2009.

————. *Relocations: Selected Art Essays and Interviews*. New York: Midmarch Arts Press, 2008, 57.

————. "Maria Frank Abrams / Gordon Woodside-John Braseth Gallery, Seattle." *Art Ltd.*, May-June 2007.

"King County Grants Go to Four Artists." *Seattle Times*, May 27, 1976, C9.

Larsen, Dick. "Tale of an Extraordinary Family: International Family Plays Part in Jewish History." *Mercer Island Reporter*, August 16, 2000.

" 'La Traviata' Sets: Center 'Factory' Builds Opera." *Seattle Times*, May 26, 1963, 11.

Lehmann, Thelma. "Set Designer for 'The Dybbuk' Scores Well on First Assignment," *Seattle Times*, January 7, 1963, 19.

————. "Maria Frank Abrams' Paintings Show Sure, Steady Development." *Seattle Times*, July 7, 1957.

"Library Mural Dedication Sunday." *Mercer Island Reporter*, January 27, 1977.

"Local Art to Kobe." *Seattle Post-Intelligencer*, December 30, 1965.

Lowry, Mrs. V. D. "Operation Abolition." *Chi Omega Newsletter*, March 1961.

"Maria Abrams in Northwest Exhibit," *Mercer Island Reporter*, October 21, 1977, 20.

"Maria Abrams Wins Prize for Design." *Seattle Times*, September 27, 1964.

"Maria Frank Abrams' New Work . . ." *The Arts—Newsletter of the Seattle and King County Arts Commissions*, January 1977.

"Marika Abrams Paintings on View at Seligman Gallery Nov. 3 to 26." *The Transcript* (Seattle), October 29, 1956.

"More Northwest Artists . . ." *Seattle Times*, April 17, 1987.

Morgan, Linda. "Gallery Hosts Watercolor Exhibition." *Mercer Island Reporter*, October 29, 1997.

"Mrs. Abrams Designs Sets for 'La Traviata.'" *Seattle Times*, April 28, 1963.

"New Art Exhibitions Scheduled." (Portland) *Oregonian*, January 14, 1973.

Naturalism to Abstraction in Watercolor. Seattle: North Seattle Community College Gallery, 1992.

"Northwest Artist Has Local Show." *Portland Jewish Review*, March, 1970, 6.

Northwest Poets & Artists Calendar. Bainbridge Island, WA: Bainbridge Island Arts Commission, 1993.

"O. D. Seligman, Noted Patron of Local Art." *Seattle Post-Intelligencer*, February 10, 1966.

Gail Olson, "Paint a Song of Happiness." *Seattle Post-Intelligencer*, January 6, 1967.

"Opening at Moldrem." *Seattle Times*, June 5, 1974.

Opera Committee of the Seattle Jewish Community Center, Inc., *The Dybbuk: An Opera in Three Acts*. Michael White, composer. George Bluestone, librettist. World premiere January 5, 1963, Seattle, Washington.

"Organic Forms Easily Dominate . . . " *Seattle Times*, March 16, 1976.

"Otto Seligman, Gallery Owner." *Seattle Times*, February 10, 1966, 49.

"Outstanding Artists Featured at Jewish Community Center." *Mercer Island Reporter*, May 29, 1975, 17.

Phillips, Margery R. "Two-Level House on a Mercer Island Slope." *Seattle Times Pacific Northwest Living*, August 16, 1959, 22–26.

"Politics and Art." *Argus*, March 10, 1961.

Polzer, Anne. "Die Westküste: Galerie-Besuch in Seattle." *Aufbau* (New York), August 16, 1957.

Reed, Gervais. *Artists of the Seattle Region: An Invitational Exhibition*. Seattle: Henry Gallery, University of Washington, 1956.

"Reflections . . . " *Seattle Post-Intelligencer*, March 5, 1976.

Raleigh, Sally. "Murals Show Seattle Scene." *Seattle Post-Intelligencer*, May 25, 1961.

"Ready for Auction." *Seattle Times*, January 18, 1970.

Russell, Norma. "Guest Cook: Artist Explains Her Feeling of Painting." *Bellevue American*, December 28, 1966, 1.

"Seattle Art Museum Guild Plans to 'Travel.' " *Seattle Times*, September 27, 1964, S9.

"Seattle's First Art Show in Church Opens Today." *Seattle Post-Intelligencer*, May 10, 1961.

Seligman, Otto. *Northwest Artists of the Seligman Gallery*. Seattle: Otto Seligman Gallery, 1962.

———. *Artists Showing at the Seligman Gallery*. Seattle: Otto Seligman Gallery, 1967.

"Seligman Has Two-Man Show for December." *Seattle Times*, November 29, 1966.

"The Smart Set." *Seattle Post-Intelligencer*, July 17, 1955.

The Spring Art Show. Seattle: University Unitarian Church, 1961.

"Sparkling Spring." *Seattle Post-Intelligencer*, May 16, 1954.

"Strong Images . . . " (Portland) *Oregonian*, May 4, 1975.

"Suburban Hadassah Plans Luncheon." *Mercer Island Reporter*, December 14, 1967, 4.

Tarzan, Deloris. "Minuzzi Gears Up for Surrealism." *Seattle Times*, June 18, 1974, A16.

———. "Watercolor Jurors Disagree." *Seattle Times Tempo*, May 10, 1974, 3.

———. "Strong Chemistry in Watercolor Show." *Seattle Times*, May 16, 1975.

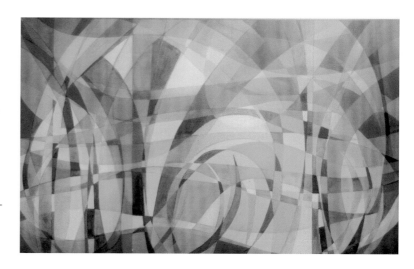

Figure 76
Design for *Waterfront* mosaic at Seattle Center, 1974
Watercolor on paper
13 ¼ x 22 ¼
Agnes Jacobson collection, Santa Barbara, California

———. "Art World Has New Looks, Promotions, Winners." *Seattle Times*, March 16, 1976, D4.

———. "Drawing Show Traces Art Revolution." *Seattle Times*, October 9, 1977, J10.

———. "Watercolor Show Finds a New Museum." *Seattle Times Tempo*, May 20, 1977, 3.

"The Artist: A Minority Within Another Minority." *Seattle Post-Intelligencer*, December 4, 1967.

Thirty-eighth Annual Exhibition of Northwest Artists, Seattle: Seattle Art Museum, 1952.

Thirty-ninth Annual Exhibition of Northwest Artists. Seattle: Seattle Art Museum, 1953.

Todd, Anne G. "Maria Abrams, Chong Exhibit at Seligman's." *Seattle Times*, April 5, 1958.

———. "Women's Art Refutes Cliché Idea." *Seattle Times*, April 16, 1961, S11.

———. "Sangeeta's Medium Seems Almost Alive." *Seattle Times*, November 25, 1962, 70.

———. "Two Mount Vernon Artists Show Here." *Seattle Times*, December 21, 1966, 57.

———. "He Stood High: Seligman's Passing Saddens Art World." *Seattle Times*, February 11, 1966.

Twersky, Reva K. "Hillel Aid Opened a World of Art to Seattle's Maria Frank Abrams." *The National Jewish Post*, July 23, 1954.

"Visual Arts: Gallery West." *Willamette Week* (Portland, OR), May 5, 1975.

Voorhees, John. "Art Museum Engagement Book Outstanding." *Seattle Post-Intelligencer*, November 21, 1955, 8.

———. "Gallery Has Strong, Beautiful Show." *Seattle Post-Intelligencer*, August 17, 1961.

———. "White's Opera in Premiere." *Seattle Post-Intelligencer*, January 7, 1963.

———. "East Side Galleries." *Seattle Times*, March 6, 1970.

———. "Watercolor Show Is Long on Variety." *Seattle Times*, January 18, 1970, D9.

———. "Visual Arts: Abrams' Show Has Diversity of Styles." *Seattle Times*, January 31, 1972, C5.

———. Art Show Jury." *Seattle Times*, July 28, 1957.

Wagoner, David. "Verdi's 'La Traviata' Thrills a Near Capacity Audience at Opera House." *Seattle Times*, June 7, 1963.

"Winter Morning." *Seattle Post-Intelligencer*, May 29, 1977.

SELECTED WRITINGS AND INTERVIEWS WITH THE ARTIST

Abrams, Maria Frank. "What Informs an Artist's Work?" Charles and Emma Frye Art Museum, Seattle, November 15, 2001, lecture.

"Artist Maria Frank Abrams . . . " *The Province* (Vancouver, BC), February 17, 1967, 23.

Barling, Ann. "Concentration Camp Friends: 'Emotional' Reunion Arranged." *Vancouver* (BC) *Sun*, February 16, 1967, 36.

Brazier, Dorothy Brant. "Busy Life Dims Memory of Nazis." *Seattle Times*, May 8, 1959.

Englehart, Janice. Interview with Maria Frank Abrams, *Survivors of the Shoah: Visual History Foundation*, December 8, 1995. Part I, 1 hr., 40 min.; Part II, 2 hrs., 26 min. Transcribed by Sharon Prosser, 2009.

Gray, Stuart. "She Was with Anne Frank." *The Province*, February 15, 1967, 25.

Mahoney, Sally Gene. "Woman's Role in Art, World Topic for Artist's Speech." *Seattle Times*, December 1, 1967.

McDonald, Lucile. "She Paints 'Fragments of Dreams': The Nightmare of Nazi Horror Camps Fades as Maria Abrams Transfers Her Moods to Canvas." *Seattle Times*, January 24, 1954.

Miller, Stephanie. "From Auschwitz: A Declaration of Faith in Humanity." *Seattle Post-Intelligencer*, January 23, 1972.

Rhodes, Elizabeth. "A Voice from the Holocaust: Marika Frank Abrams Is the Only Survivor from Her Family." *Seattle Times Pacific Magazine*, April 11, 1982, 16–29.

Rothchild, Sylvia, ed., and Elie Wiesel, foreword. *Voices from the Holocaust*. New York: New American Library, 1981, 47–50; 187–195; 314–322.

Swenson, Sally. Interview with Maria Frank Abrams. Archives of Northwest Art, University of Washington Libraries Special Collections, March 20, 1974. Cassette C-90.

Tanzer, Shirley. "Mrs. Marika Frank Abrams." William E. Weiner Oral History Library, American Jewish Committee Holocaust Survivor Project, January 15–16, 1976; February 10, 1976.

ABOUT THE AUTHORS

 MATTHEW KANGAS is the author of numerous publications including *Robert Willson: Image-Maker* (Pace-Willson Foundation, 2001), which was a finalist for the Washington State Book Awards, as well as three collections from Midmarch Arts Press: *Epicenter: Essays on North American Art* (2004), *Craft and Concept: The Rematerialization of the Art Object* (2006), and *Relocations: Selected Art Essays and Interviews* (2008). He is a corresponding editor for *Art in America*. Photo: Christopher Dahl

 DEBORAH E. LIPSTADT is Dorot Professor of Modern Jewish and Holocaust Studies at Emory University in Atlanta. *History on Trial: My Day in Court with a Holocaust Denier* (Ecco, 2006) is the story of her libel defense in London against Holocaust denier David Irving. It won the National Jewish Book Award. She is also the author of *Beyond Belief: The American Press and the Coming of the Holocaust 1933–1945* (Touchstone, 1993). Photo: Jillian Edelstein

 PETER SELZ is Professor Emeritus of the History of Art at the University of California, Berkeley. Among his many books are *Art of Engagement: Visual Politics in California and Beyond* (University of California Press, 2006); *Art in a Turbulent Era* (1985); *Max Beckmann* (1964); and *German Expressionist Painting* (University of California Press, 1957). He won the College Art Association Charles Rufus Morey Award in 2007. He is a corresponding editor for *Art in America*. Photo: Alan Bamberger

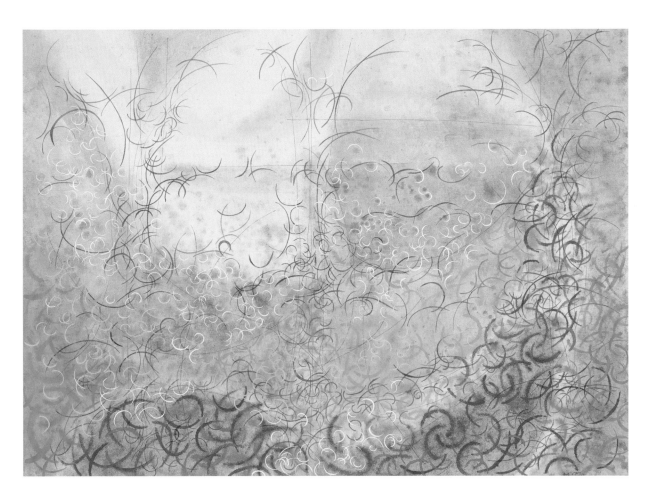

Figure 77
Untitled (Organic Abstraction), 1966
Casein, pen and ink with wash on paper
14 ¾ x 22 ¾
Gift of the artist
Jundt Art Museum
Gonzaga University, Spokane, Washington

ACKNOWLEDGMENTS

Kőszőnet nyilvánitás

A great number of people have been involved in this project. First and foremost I want to recognize the support and unflagging encouragement of Sydney Abrams, whose enthusiasm and determination to make this project happen have been an inspiration and example of selfless devotion. Maria Frank Abrams helped with memories added to her oral histories and occasional confirmation of dates and names. Her patient understanding and considerable assistance has made this book possible. She graciously opened her studio and personal archives of family scrapbooks, letters, and other material to me. Their son, Edward, not only helped confirm crucial dates and facts, but made significant comments that strengthened the historical dimension of the sections on the Holocaust in Hungary. Omri Abrams, the Abramses' grandson, became unofficial photo archivist while visiting Seattle, and spent weeks creating the first chronological archive of her slides and other images. Mrs. Abrams's cousin, Vera Frank Federman, made immeasurable contributions to my understanding of the context of life in Debrecen, in addition to going over the manuscript carefully to check facts and Hungarian spellings. Thanks also go to the extraordinary generosity of David Current and Sharon Prosser of Current Rutledge, who have made it possible for the invaluable source of Mrs. Abrams's interview with Janice Englehart for the *Survivors of the Shoah* Project to be transcribed for the first time.

Greg Robinson, Kathleen Moles, and Lisa Young of the Museum of Northwest Art have been invaluable in their advice and moral support for this publication as part of their ongoing examination of Northwest art.

In the studio, Ellen Ito, Marty Gegenbach, and Nicholas Nyland made extensive preparations prior to visits by museum curators, including Elizabeth Brown and Sara Krajewski of the Henry Art Gallery, University of Washington; Kathleen Moles, formerly of Whatcom Museum of History & Industry and currently at the Museum of Northwest Art; and Scott Patenode from Jundt Art Museum, Gonzaga University, to all of whom I am very grateful for their thoughts and decisions.

In Hungary, Dr. Katalin Keresztesi acted as an untiring translator, liaison, and guide in Budapest, while Réka Britschgi smoothed the way for all arrangements and interviews in Debrecen. Dr. and Mrs. Zoltan Kramar were essential consultants who helped with translations of the chapter headings and many other details. I am indebted to Tom and Veronika Fehér and their friend, Erzsí Szücscine, for the comfortable accommodations and many courtesies I enjoyed in Budapest. The museum officials and others who kindly made possible the loan of photographs include Tibor Fényi, director Miksa Róth Memorial Museum; and Judit Faludy and Zsuszanna Toronyi, Hungarian Jewish Museum, Budapest. Edith Zámbori, receptionist for the Debrecen Jewish Community Center, helped find records of the Frank family and her husband, István Zámbori, guided me as caretaker for the Debrecen Jewish Cemetery to find the Rózsa family tombstones. Tibor Fischer and Sándor Garamvölgyi took time to talk to me about Debrecen before and after the war. Michael Levin and Jim Stapleton helped with other connections in Budapest.

Back in North America, I am grateful to Judy Sourakli, collections manager, Henry Art Gallery, University of Washington; Dr. Jody Blake, curator, and Heather Lammers, Tobin Collection of Theatre Arts, McNay Art Museum, San Antonio; Nicole Bouché and

Gary Lundel, Special Collections, University of Washington Libraries; Arthur Hall Smith, Paris; Francine Seders, Seattle; Vera Federman, Mercer Island, Washington; Ann LaRiviere, Portland, Oregon; Harriet Bodmer, Portland, Oregon; Hillary Huggins, Dr. Susan T. Gardner, Estika Hunnings and Lori-Ann Latremouille in Vancouver, BC; Joann Perri, King City, Oregon; Joseph E. and Ofelia Gallo, Modesto, California; Arthur and Alice Siegal; Olga and Henry Butler; and Joan Hansen. Finally, Tony Emery and John Braseth of Gordon Woodside / John Braseth Gallery pointed the way toward paintings that might not otherwise have come to my attention.

While Richard Nicol undertook the lion's share of photography with his customary grace and efficiency, thanks also go to the other photographers and agents who helped make possible the range of images and their high quality: Chiyo Ishikawa, Sarah Berman, and Lowell Bassett of Seattle Art Museum made a difference, as did Lisa Young and Greg Robinson, Museum of Northwest Art; J. Craig Sweat, Jundt Art Museum; and Kirk Eck, Wichita Art Museum. Christine Charbonneau and Brian Cutler, Planned Parenthood of the Great Northwest, also helped in allowing paintings be photographed easily.

Cyrus Charters of Seattle Printing made a substantial contribution throughout the project.

Ruri Yampolski, Joan Peterson, and Deborah Payne of the Office of Arts and Cultural Affairs, City of Seattle, located photographs of works in their collection. Esther Luittikhuizen of King County 4Culture confirmed holdings in the county art collection. Andras Zwickl and Tibor Mester of the Hungarian National Gallery, Budapest; officials of the Ferenc Moma Museum, Szeged; and Angus Bungay, Vancouver, BC, also facilitated the use of images.

Finally, Phil Kovacevich of Kovacevich Design brought all the material together into an easily readable and beautifully designed document that is a tribute to Mrs. Abrams and the pride of this author. Phil has been assisted by the thoughtful editing of Sigrid Asmus, and helped by all the individuals who lent photographs, some of whom are listed above, others of whom have chosen to remain anonymous. Sheryn Hara of Book Publishers Network has made enormous efforts to assure wide access for the publication. To everyone, many thanks for your contributions of time and assistance.

— Matthew Kangas

This book has been typeset in Centaur, an old-style serif typeface originally drawn as titling capitals by Bruce Rogers in 1912–14 for the Metropolitan Museum of Art. Headings are set in Sackers Gothic. Book design and composition by Phil Kovacevich. Printed on archival-quality paper at Friesen's Inc., Canada.

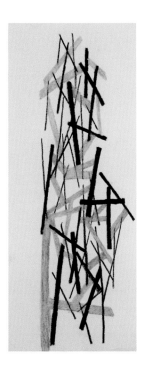

INDEX

Special appreciation to Joseph E. and Ofelia Gallo, Modesto, California, long time collectors and friends of Maria Frank Abrams, for their vital support of this publication.